Learn to Paint

GARDENS
IN WATERCOLOUR

Sharon Finmark

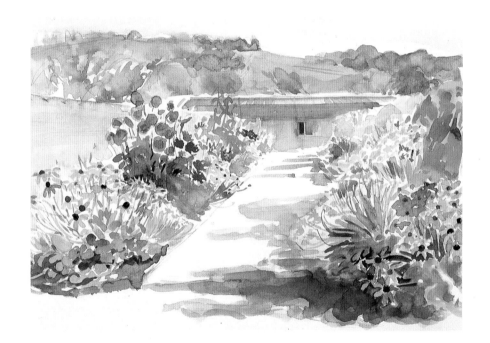

HarperCollinsPublishers

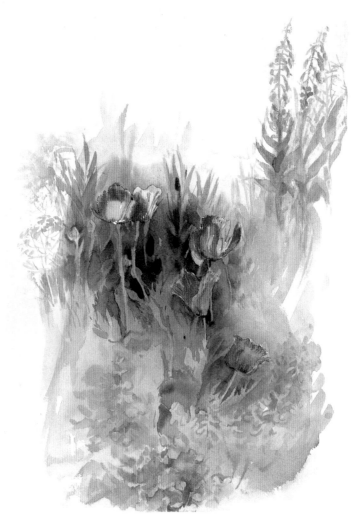

'To Marek's computer'

First published in 1996 by
HarperCollins Publishers, London

© Sharon Finmark 1996

Sharon Finmark asserts the moral right to be
identified as the author of this work.

**A catalogue record for this book is available
from the British Library**

*Editor: Hazel Harrison
Designer: Amzie Viladot
Photographer: Jon Bouchier*

ISBN 0 00 412743 9

Colour reproduction by Colourscan, Singapore
Printed and bound by Rotolito Lombarda SpA, Milan, Italy

PREVIOUS PAGE: West Dean Garden
25.5 × 33 cm (10 × 13 in)

THIS PAGE: Poppies
38 × 29 cm (15 × 11½ in)

OPPOSITE: West Dean Arch
28 × 37.5 cm (11 × 14¾ in)

CONTENTS

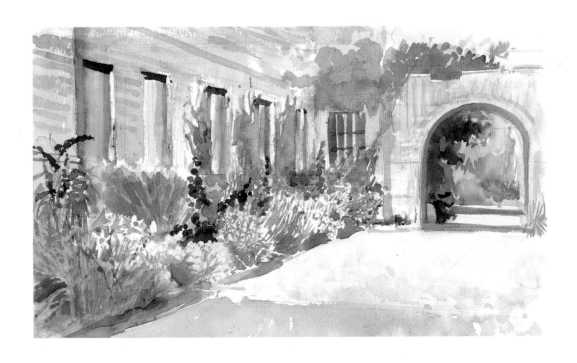

PORTRAIT OF AN ARTIST
SHARON FINMARK

Sharon Finmark was born and brought up in London, where she still lives, although she has travelled and painted widely in Europe. An only child, she began to paint at about the age of nine and her interest in school work, with the exception of geography lessons where she could produce lavishly illustrated maps, was quickly usurped by her new-found fascination with painting.

She trained as an illustrator, having abandoned an art-school fine-art course because she wanted to work figuratively – a style of painting perceived to be unfashionable at that time. From 1973 to 1976 she was primarily employed in this capacity, working in a wide range of media

for national newpapers and magazines, book publishers and fine-art card makers. She still accepts commissions for illustrative work, but now concentrates most of her energies on her own painting, and on teaching. Since 1980 she has been increasingly employed as a visiting lecturer, giving short courses on painting and drawing in various institutions including the Garden School, Chelsea Physic Garden and West Dean College.

She paints a wide range of subjects, in all the media, though is best known for her work in watercolour and pastel. She became especially interested in landscape while living in Norfolk

in the 1970s, and the idea of painting gardens was a natural development from this, spurred by a visit to a friend who was a landscape-garden designer. After spending most of her life in urban flats, with little more than a window box, she now has her own garden, a source of inspiration in both artistic and horticultural terms.

▲ *Sharon Finmark painting in a friend's garden*

4

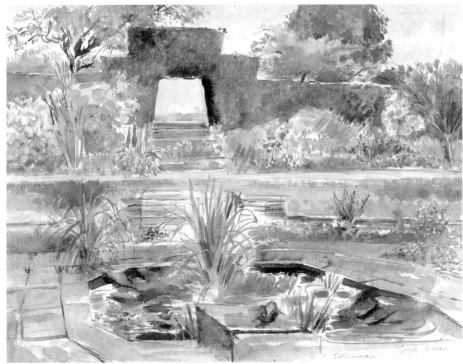

▲ St Mary's, Twickenham
28 × 37.5 cm (11 × 14¾ in)

◄ Great Dixter
28 × 37.5 cm (11 × 14¾ in)

WHY PAINT GARDENS IN WATERCOLOUR?

Anyone who enjoys both painting and flower-growing must have considered their garden as a possible subject, and what better way could there be to celebrate your horticultural achievements? You can, of course, take photographs when the garden is at its best, but these will only go part way towards expressing your feelings, whereas a painting completes the creative process that began with planning and planting the garden.

And if you are a non-gardener you can enjoy the gardens created by others. There are parks with fine gardens, and a wealth of 'special' gardens open to the public where you can find a quiet spot in which to work relatively undisturbed.

The most obvious attraction of gardens is the riot of colour and variety of different shapes and forms. But there is another aspect too; a garden is an enclosed space, a landscape in miniature, which makes it at once an exciting and a comfortable subject; you can feel more secure in a garden than you would when painting a wild expanse of untamed landscape.

The medium of watercolour seems almost tailormade for garden paintings. Because the medium is quick to use, it is ideally suited for capturing quick impressions – perhaps that particular time in the season when breezes begin to blow the blossom from the trees, or a

moment in the day when sun breaks through clouds to spotlight a rose bush or clump of daffodils. But you can achieve a lot of fine detail with watercolour too, so it is equally suited to more precise effects if that is where your interests lie.

There are, of course, difficulties inherent in the subject matter, but I hope this book will help to solve them. Composing the picture can be tricky, as there are often so many different possibilities to choose from. Also, there is a tendency to become obsessed with botanical accuracy, sometimes to the detriment of the picture. In many of the paintings and demonstrations that follow, I show how you can simplify while still giving enough information to create the impression of particular flowers or shrubs. To do this you need to understand the capabilities of the medium, so I explain the basic techniques as well as suggesting some useful 'tricks of the trade' that you may enjoy trying out.

▲ A London Garden
32 × 37.5 cm (12 ½ × 14 ¾ in)

And last but not least, I have tried to show something of the diversity of the subject matter through my choice of paintings for the book – a garden can be anything from sweeping landscaped parkland or classical statuary and fountains to a few flowerpots on a balcony or the corner of a patio. Even if you have no garden as such, look around you and you will find suitable subjects everywhere.

▲ The Principal's Garden, West Dean
30 × 29 cm (11¾ × 11½ in)

MATERIALS AND EQUIPMENT

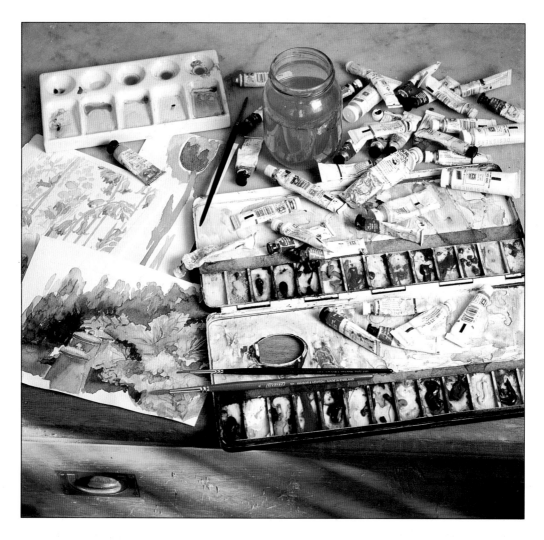

If you are a complete beginner you may need some guidance in purchasing materials and equipment – the range of choice of colours, papers and brushes can be extremely confusing. Those who have had some experience in using watercolours before will no doubt have worked out their own personal kits, but even so may find that this chapter provides some useful hints and tips.

COLOURS

It is best to start with a small range of colours, discover what you can and cannot achieve by mixing them, and buy more when the need arises. The essential colours are the primaries – blues, reds and yellows. You will need two of each: Cadmium Red and Alizarin Crimson, Cadmium Yellow and Lemon Yellow, Ultramarine and Prussian Blue.

▲ *I am often asked whether I prefer tubes or pans. Both have their place, but I find tubes ideal for larger work where I need lots of watery paint for washes and a highly charged brush for intense colour. I use Daler-Rowney Artist's Quality paint, and squeeze out the colours into the compartments of this metal paintbox. The colours can be kept from session to session so there is no wastage. I like to have an auxiliary palette as well in case I need more space for mixing.*

I also suggest one or two greens such as Winsor Green or Viridian, and Sap Green, plus three browns – Raw Sienna, Burnt Sienna and Vandyke Brown.

To capture the vividness of certain flowers it is worth having a few unusual colours such as Rose Doré (or Permanent Rose), Cerulean Blue and perhaps Winsor Violet, but don't rush into purchasing these until you have explored the possibilities of colour mixing.

PAPER

Watercolour paper is made in three different surfaces: smooth (called Hot-pressed or HP), medium (called Not) and Rough. The one used by most watercolour painters, including myself, is Not. It has a texture, but not enough to interfere with detail, while Rough paper is so heavily textured that it breaks up the brushmarks. This can be effective, but is tricky to handle. I sometimes use HP paper, particularly when I am in a hurry, as the smooth surface allows you to cover the paper very quickly, but it doesn't hold the paint in place so well, so you are likely to get pools and puddles.

Paper is also made in different weights, expressed as gsm or lbs. The most common, and that normally used in watercolour-paper pads, is 300 gsm (140 lbs), but if you buy paper by the sheet you can choose a much heavier one, up to 640 gsm (300 lbs).

The advantage of heavy paper is that it doesn't buckle when you put on wet washes. Even 300 gsm paper will do this if you use a lot of water, so you may need to stretch it first, and you should certainly do this with any lighter

paper. Damp the paper all over on both sides, either with a sponge or by putting it in the bath, lay it on a drawing board and stick brown gummed tape all round the edges. Once the paper has dried it will be flat and taut.

▲ *Watercolour paper can be bought in loose sheets, pads and blocks. The latter are useful, as the paper is bound on all four edges, which avoids the necessity of stretching. A piece of stretched paper is shown at middle right of this photograph, together with the gummed strip – never use Sellotape or masking tape. At the front you can see the three paper surfaces: Rough (left), Hot-pressed (centre) and Not (right). Notice how the paint behaves differently on each surface.*

BRUSHES

Sable brushes are ideal for watercolour work, but these are very expensive, and I don't recommend them for a starter kit. Those made from a mixture of synthetic and animal hair are fine. Brushes come in both round and flat shapes, the former being the most versatile, as you can make broad strokes with the brush well loaded with paint, and achieve fine lines with the point. You will need at least two of these – one large one (Nos. 8, 10 or 12) and one small (Nos. 3 or 5). You may also find one large flat brush useful for washes, or alternatively a soft mop brush made of squirrel hair or nylon.

OTHER EQUIPMENT

You will need a jar for holding water and a palette for mixing colours. Here the choice will depend on whether you use pans or tubes of paint. Pans are made to fit into small compartments in a paintbox, with the large compartments used for mixing. If you buy the paint in tube form you can use more or less anything as a palette – an old tin plate, for example. Or you can buy one of the custom-made china or plastic palettes; most art shops stock a variety of these.

If you are using a loose sheet of paper to paint on you will have to support it on something, so a drawing board is a requirement, plus masking tape or bulldog clips for securing the paper. There is no need to spend a lot of money on a drawing board; a sheet of hardboard or furniture board is quite adequate (but don't use hardboard for stretching paper as it may warp).

These are my brushes, though I seldom if ever use all of them in one painting. Often I restrict myself to two or three round brushes, particularly when working outside. The housepainter's brush is handy for large overall washes.

Pencils will be needed for making preliminary drawings, plus an eraser – we all make mistakes – and a pencil-sharpener or craft knife. I suggest an HB and a 2B pencil; avoid anything harder as it may indent the paper. A small natural sponge is handy, for lifting out, softening edges and removing unwanted pools of paint, but this is not essential.

OUTDOOR EQUIPMENT

Since you are going to be working out-of-doors, be prepared for both sunshine and rain, and take suitable clothing such as a sunhat and a waterproof. A plastic bag is a good idea for protecting your painting in case of sudden showers.

You will need a light folding stool unless you are sure there is somewhere to sit. Choose a low one so that you can have your materials on the ground by your side. Easels are useful, although cumbersome. If you buy one, make sure it can hold your board flat or almost flat, as otherwise the watercolour will run down the paper.

There is always a danger of spilling precious water, so consider one of the plastic water pots with non-spill tops, and don't forget that you may need to change the water during your working session, so take a supply in a light plastic bottle. Mineral-water bottles are ideal.

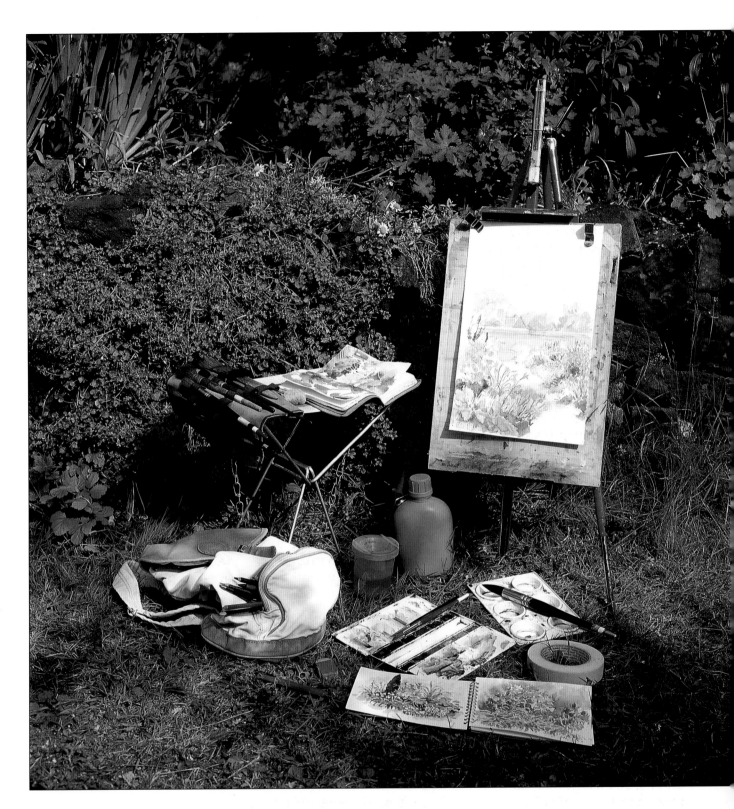

▲ I find an easel essential when I am working on a large scale. This metal one can be adapted to any angle, and I would not usually work with the board held upright. When I set out to paint, I take a board with a sturdy paper clipped to it and attached to the easel.

I use a non-spill water pot, a plastic bottle for extra water, and have a light canvas bag that holds all my equipment. If I am only making small sketches I dispense with the easel and use the Langton spiral-bound watercolour pad shown in the front.

COLOUR

There are two major aspects to using colour. The first is mixing it correctly so that it corresponds to something in your subject, and the second is to exploit relationships and contrasts of colour to make your paintings say more. I am beginning with the more theoretical aspects of colour, because it is easier to mix colours when you understand something about their nature.

PRIMARY AND SECONDARY COLOURS

The first thing you need to know is that there are three colours that cannot be produced from mixtures of other colours. These – red, yellow and blue – are called the primary colours, and mixtures of any two of these produces a secondary colour – red and yellow make orange; red and blue make purple, and blue and yellow make green. In the colour wheel you can see the secondaries between the primaries.

WARM AND COOL COLOURS

Notice that the colour wheel shows two different reds, blues and yellows. Colours are described as 'warm' or 'cool', and each primary colour has a warm and cool version. One of the blues, for example, is greener (cooler) than the other, and one of the reds more yellowy (warmer). The kind of secondary colour you make depends upon which pair of primaries is chosen. For a sharp, clear green, choose the cool blue and yellow; for a richer green use the warm ones.

The 'temperature' of colours is not only important in colour mixing; it has wider implications for your painting. The cool colours tend to recede into the background and the warm ones to come forwards to the front of the picture, so if you use cool greens in the background of a

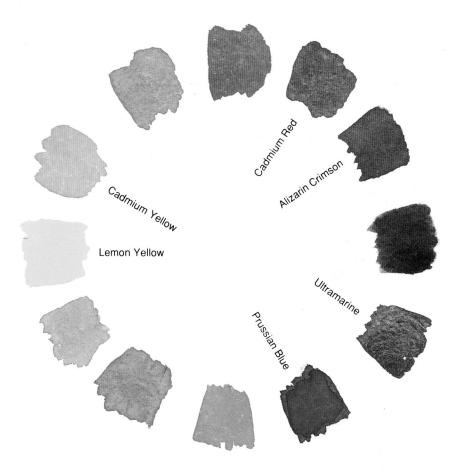

▲ *This wheel shows six primary colours (two versions of each), with the secondary colours between them. These secondaries are ready mixed tube colours, but you can make your own by combining two primaries, varying the hues by altering the proportions.*

garden painting, perhaps for massed shrubs or trees, and bright, warm ones in the foreground, you will create the impression of space and depth.

COMPLEMENTARY COLOURS

To go back to the colour wheel again, you will see that red falls opposite green; blue opposite orange, and yellow opposite purple. These pairs of colours are called complementaries, and when you use them together they give an extra punch to your painting. You may have noticed how reds look particularly brilliant when surrounded by green foliage. Gardens provide many of these exciting contrasts, which you can exploit in your paintings.

NEUTRAL COLOURS

Complementary colours are also useful in the context of colour mixing. Each complementary pair is composed of one primary and one secondary colour: red (primary), green (secondary) and so on. If you mix these together they neutralize one another, because you are in effect mixing all three primaries. This is a useful way of producing neutral colours such as browns and greys, and is particularly effective when these colours are placed next to a full-strength primary colour. The proportions can be varied to produce a large range of hues, and made pale or dark according to the amount of water added. These mixes produce subtle, muted colours – very useful for shadows, architectural features and autumnal tones.

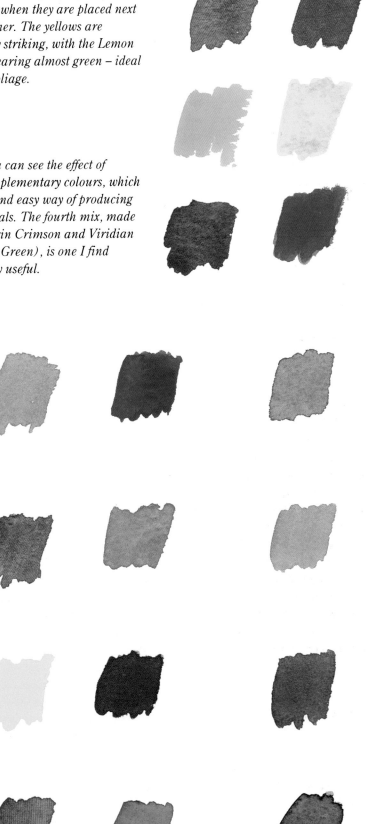

▶ *You can see the difference between the warm and cool primary colours very clearly when they are placed next to one another. The yellows are particularly striking, with the Lemon Yellow appearing almost green – ideal for spring foliage.*

▼ *Here you can see the effect of mixing complementary colours, which is a quick and easy way of producing lively neutrals. The fourth mix, made from Alizarin Crimson and Viridian (or Winsor Green), is one I find particularly useful.*

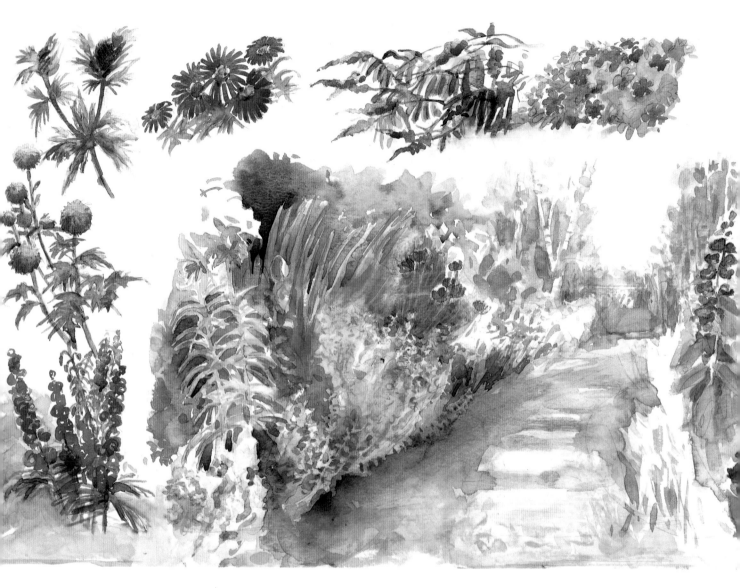

▲ *I made the detailed vignettes of the flowers originally as an aide-mémoire for my broader work, and then played around to make them into a border for the picture. I have a particular affection for blue, and wanted to create a harmonious composition playing on the variety within this hue, using Cobalt and Ultramarine in a range of tints.*

HARMONIOUS COLOURS

Contrasts occur naturally in garden subjects, but so do harmonies, indeed beds and borders are often planted with the principle of colour harmony in mind. Harmonious colours are those that are near one another on the colour wheel, such as blues and violets, reds and pinks, yellows and oranges. If you stick to colour harmonies your picture will have an overall unity of colour and create a gentle, restful effect that suits the subject. However, too much harmony can become dull – think of a landscape with nothing but green – so you might consider introducing a touch of complementary colour for contrast. The 19th-century French painter Corot often placed a small red-clad figure in his lush green landscapes.

COLOUR MIXING

There is nothing wrong with using colours straight from the tube, diluted with water in varying amounts to produce variations in tone (lighter or darker). But often you will have to mix; those subtle and elusive colours don't come ready-made in tubes or pans.

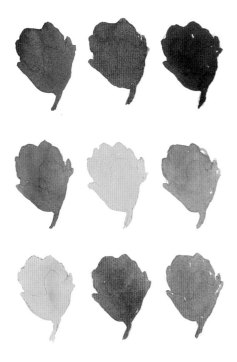

▼ *In this case, the colours have been mixed by overlaying on the paper when the first wash had dried.* **a**: *Ultramarine overlaid with Alizarin Crimson, then the same colours in the reverse order.* **b**: *Cadmium Yellow overlaid with Cadmium Red, then reverse order.* **c**: *Winsor Blue overlaid by Cadmium Yellow, then reverse. Notice that where a light colour is laid over a darker one the colour change is less obvious.*

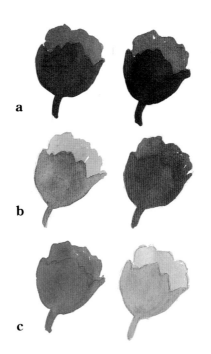

▲ *These show two primary colours mixed to produce a secondary one. The first two flowers are the pure primaries, and the third is the mixture. They are: Ultramarine and Alizarin Crimson, mixed to make purple; Winsor Blue and Cadmium Lemon, making a sharp green; Cadmium Yellow and Cadmium Red, which makes orange.*

▲ *Here I have used the third method, mixing colours by flooding them into one another wet-into-wet.* **a**: *Alizarin Crimson flooded with Ultramarine.* **b**: *Cadmium Yellow flooded with Cadmium Red.* **c**: *Winsor Blue flooded with Cadmium Lemon. Notice how the first mixture has granulated slightly; Ultramarine is one of the pigments that tends to break up, an effect which is noticeable even in the wet-on-dry example.*

Beware of over-mixing, a pitfall when you are not sure how to achieve a particular colour. The more colours you use in a mixture the less pure the colour is, so if you start off with a three- or four-colour mixture and then lay further colours on top you will end up with a pool of mud. A good rule is to restrict yourself to two colours – three at the most.

METHODS OF MIXING

There are three methods of mixing colours, the first being simply to combine them in the palette before applying to paper.

Obviously you will need practice before you can get the mixtures exactly right, and you will need to become familiar with your palette of colours – some colours are stronger than others and will dominate a mixture. All this will come in time, but to make sure a mixture is right before you use it, try it out on a spare piece of paper, let it dry and hold it up to the subject. You will quickly see whether it needs adjusting.

The second method is to mix on the paper itself by laying one wash over another dry one. This is something you will probably do without fully realizing it in the course of a painting, at least in

small areas, but you can do it quite deliberately. A background of green trees or shrubs, for example, can be deepened and enriched by laying a wash of blue over it.

The third method also involves mixing on the paper surface, but in this case working wet-into-wet so that two or three colours 'bleed' into one another. This creates a very different effect, as the colours only mix partially, so it is good for any area of colour where you want a soft but not a flat effect. I use all three methods depending on the circumstances, and you will soon discover which one suits the subject matter best.

COLOUR QUALITIES

As I have mentioned already, some colours are stronger than others – the reds are particularly powerful, and so is Prussian Blue. Colours also vary in their degree of transparency. The more transparent colours such as Alizarin Crimson, Sap Green and Winsor Blue and Green, are useful in mixtures, but it is as well to remember that they stain the paper, so that once the colour has dried you cannot remove it completely by lifting out.

Yellow Ochre and Cerulean Blue are both relatively opaque, and in mixtures the pigment tends to break up and float on the surface, producing a granular wash. This can create an interesting effect, which artists often encourage, but a word of warning. Take care with Yellow Ochre in mixtures for greens: if you use too much it will deaden the colour.

MIXING GREENS

In landscape subjects, green is always the colour that worries people most because there are so many different greens in nature. Theoretically, you should not need any ready-made greens, as they can be mixed from blue and yellow, but most artists have one or two, as it saves time, and the most obvious choices are Sap Green, Hooker's Green and Viridian. All these can be the basis of mixtures; they can be used on their own, but often you will need to modify a ready made green with a touch of added blue or yellow. But do try mixing greens from 'scratch', as this is useful practice and helps you to understand and analyse colours.

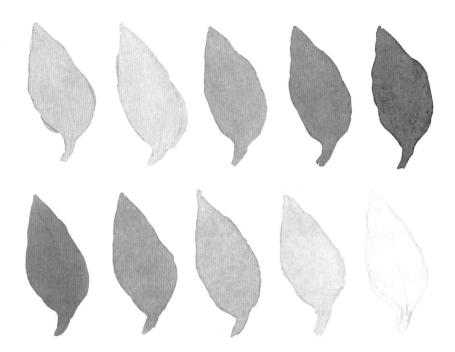

▲ *These examples show how a surprisingly wide range of greens can be produced from just two colours – Cadmium Yellow and Winsor Blue – mixed in the palette. I have varied the proportions and the amounts of water to make both warm and cool, light and dark greens. The central colour in the top row is a half-and-half mixture, with more yellow used on the left and more blue on the right.*

▲ *Richer, deeper greens characterize full summer. Sometimes you will only need to change the proportions of the mixtures, but you may have to experiment with warmer colours. These mixtures are, from left to right: Cadmium Yellow (warmer than Cadmium Lemon) and Winsor Blue, Winsor Green and Alizarin Crimson, Prussian Blue and Cadmium Red.*

▲ *In springtime, the colours are clean, sharp and new-looking. I have used, from left to right: Cadmium Lemon and Winsor Blue, the same mix with a touch of Raw Sienna, Sap Green on its own, Hooker's Green on its own.*

▲ *In autumn and winter, greens either disappear or become mellower, turning gradually to yellows and oranges. I have used Burnt Sienna and Prussian Blue for the quiet green, and Alizarin Crimson and Raw Sienna for the slightly muted orange.*

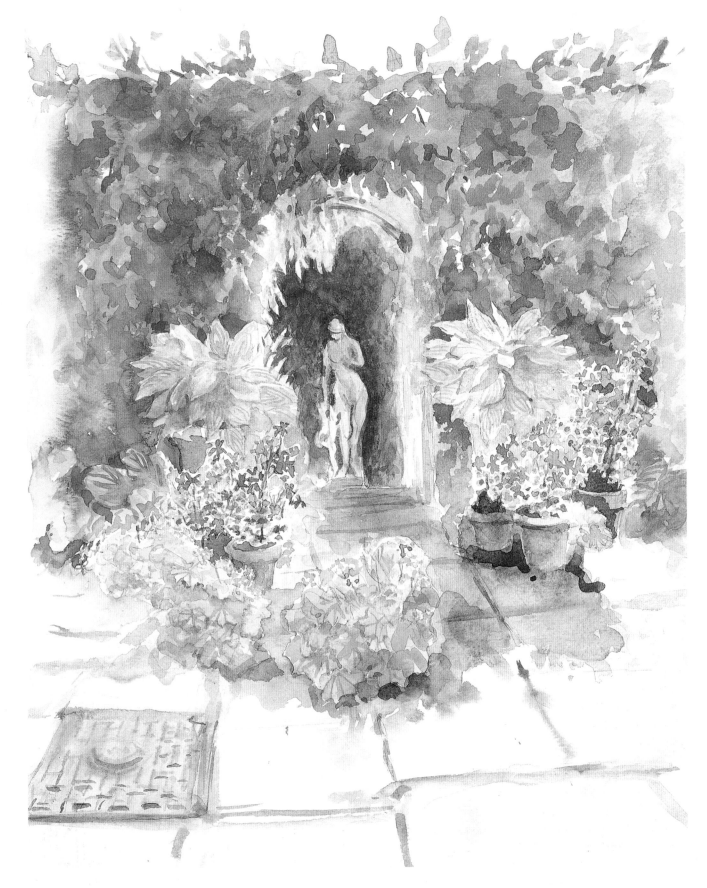

▲ Highgate Gardens
35.5 × 28 cm (14 × 11 in)
In this painting you can see how the pure Cadmium Yellow in the foreground complements the mauvish *shadows, while the redness of the geraniums is enhanced by the greens. I used Winsor Green with yellow and blue in intense mixes in the centre and more dilute toward the edges.* *The dusky green of the hostas was made from Naples Yellow and Prussian Blue. The contrast between the warm yellow-greens and the cool bluish ones creates a sense of space.*

USING WATERCOLOUR

Because watercolour is transparent, it is not possible to achieve very dark or vivid colours with one application, so colours are gradually built up by laying one brush stroke or wash over another. Areas of the picture that are to remain pale are left as a light wash, or in the case of bright highlights, as white paper. There are two basic ways of building up colours, 'wet-on-dry' and 'wet-into-wet', and they are often used together in one painting.

WET-ON-DRY

This term simply means working on dry paper, or applying new colour over a wash that has been allowed to dry thoroughly. The new paint is absorbed into the surface fibres of the paper, and dries to form crisp edges. These are a characteristic of watercolour work, but if one or two edges look over-obtrusive, they can easily be softened by going over them with a brush dipped in clean water.

WET-INTO-WET

In this method, the new paint is applied before the earlier colour has dried. The pigment floats in the water on the surface of the paper, spreads out and diffuses, creating soft blurred edges between colours. On a large

scale, wet-into-wet is tricky to control, because the paint goes on moving until it has dried, though you can encourage it to flow in the desired direction by tilting your board. It is very useful for selective areas of a painting; to create a soft effect on one or two flower heads or a background feature, for example, the paper can be damped in these areas alone.

▲ *These examples show the differences between wet-on-dry and wet-into-wet very clearly. On dry paper the paint remains exactly where you put it, drying with hard edges, while on damp paper, it spreads out. Wet-into-wet is very useful wherever you want soft effects, for skies and background foliage, for example, or for the early stages of a picture. If more detail seems needed later on you can add it wet-on-dry.*

LAYING A WASH

The wash is the basis of watercolour painting. The term 'wash' is slightly confusing, as it can refer either to a broad spread of dilute watercolour or to colour applied to one particular area or shape. Many pictures are begun with an overall wash, with any bright highlights, such as white flowers or clouds in a blue sky, reserved as white paper by taking the wash around the shape. Flat washes can be laid on either damp or dry paper (use dry paper if you are reserving highlights), and you may find it useful to try out both methods, as this will teach you a lot about how watercolour behaves.

▲ *In practice, it is seldom necessary to lay completely flat washes, except sometimes for skies, but it is good practise and helps you familiarize yourself with the medium. The method is the same whether you work on damp or dry paper. Prop the board at a slight angle, and draw a broad brush, well loaded with colour, across the top of the paper. When the first 'line' is complete, repeat the process until you have reached the bottom. The tilt of the board encourages each band to flow into the one below.*

GRADED WASH

This is a wash that is not the same tone all over – it becomes lighter (more water) or darker (more pigment) with each new band of colour. Graded washes are often used for skies or for the first wash in a flat landscape. They must be done on dry paper; on damp paper the bands will run into each other and you will end up with a flat wash.

▲ *There are two ways of working. One method is to mix up three tones of wash, from dark to light, in separate compartments of your palette – or in saucers. Begin with the darkest and move down the paper with the next batch of colour, ensuring that the wash graduates gently and not in hard stripes. The other method, which is easier to control, and produces a very subtle graduation, is to use the same colour-mix throughout, but dip the brush into clean water first for each new band. This dilutes the paint by the same amount each time. For either method, if the wash is to be darker at the bottom, turn the board and work upside down.*

VARIEGATED WASHES

You can also blend two or more colours in one wash by mixing up each colour separately, laying them in successive bands and allowing them to run into one another. This sometimes produces unpredictable results, but is fun to try. Its most obvious application is for sunset skies, but it can also be used for blending different greens, blues and yellows in background foliage.

The art in all this is letting the water do the work. Once you have mastered the differences between wet-into-wet and wet-on-dry the context in which they might be used will become evident. I work a lot on damp paper and wait to let the water absorb a little, so that the marks I make are often quite blurred to begin with. I then let the paper dry and gradually build up to define the shapes.

▲ *Variegated washes are ideal for the early stages of a picture, but they need control, or the colour may spread too far. I damped the paper only in the area of the tree; the paint runs to the edge of the damp area but is stopped by dry paper. I then laid successive bands of colour, curving them in the shape of the tree so that they help to describe the forms rather than running together randomly.*

Because watercolour is such a free-flowing medium and dries flat, it might be assumed that it is difficult to suggest texture, but there are a number of techniques that can help you here. Highlights are another potential problem area – the paint can so easily slide over the edge of a shape you are trying to reserve as white paper – but there are 'tricks of the trade' for highlights too. Have a look at the following suggestions, and see if you can find ways of using them in your garden paintings. But don't overdo special techniques; always remember that technique is only a tool to help you.

LIFTING OUT

Highlights that don't require crisp, sharp edges can be easily created by blotting wet paint with kitchen paper, cotton wool, blotting paper or a small sponge. This is a useful method for leaving loose, soft spaces for clouds, or blossom against a sky. Dry paint can be removed also, either to rectify a mistake or to create a gentle highlight. In this case, use a damp sponge and a firm pressure.

MASKING FLUID

For crisp-edged highlights or intricate shapes, for example a mass of white clematis or daisies spotting foreground grass, masking fluid is ideal. This is liquid rubber solution available in art shops. You paint on the shapes and leave the fluid to dry, and you can then paint over them without worrying that you may spoil the white shape. Remove the fluid once the paint is dry, and work into the white areas with pale washes as required.

▲ *Soft highlights are impossible to achieve by the standard method of reserving as this gives hard edges. For this blossom tree, I painted a loose series of wet-into-wet pink washes and then dabbed into them with a piece of kitchen paper. Once the paint was dry I was able to define the shapes by darkening the pinks.*

▼ *Intricate shapes, as seen in this example, are extremely difficult to reserve in the normal way by painting around them. You may overwork the wash because you are trying so hard not to let the paint slop over the edges of your pencil lines. Using masking fluid lets you work freely and with confidence.*

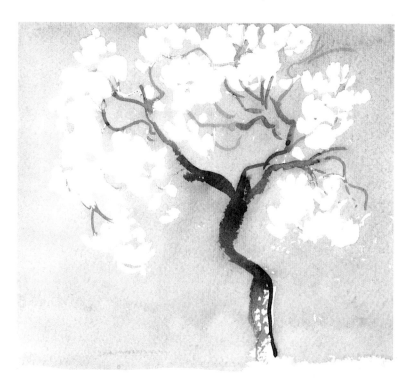

▲ *Scratching back, or sgraffito to give it its official name, is a commonly used landscape technique. You will often see small linear highlights such as these stems picked out by scraping with the point of a knife. Never do this until the final stages of the picture, as it scuffs the paper, and if you try to lay paint on top you will get unsightly blotches.*

SCRATCHING OUT

Small linear highlights, such as blades of grass catching the light in the foreground of your picture, can be created by scratching the paint away with the point of a sharp knife. To suggest texture, perhaps that of a stone wall, use the flat of the blade to remove the top layer of paint, or for a large area, scuff the paper by rubbing with medium sandpaper. Rough paper responds particularly well to this rather brutal treatment.

WAX RESIST

This is one of the best-known methods of creating texture, and is also useful for highlights. Wax is applied to the paper by drawing with a candle or wax crayon. The paint then slides off the waxed areas, creating an attractive mottling which can be ideal for tree trunks, walls and so on. For a subtle effect over a large surface, rub the candle or crayon lightly over the paper so that it catches only on the raised grain. For a thorough resist, draw heavily with the point. You could create highlights on a fence or ornamental gate in this way.

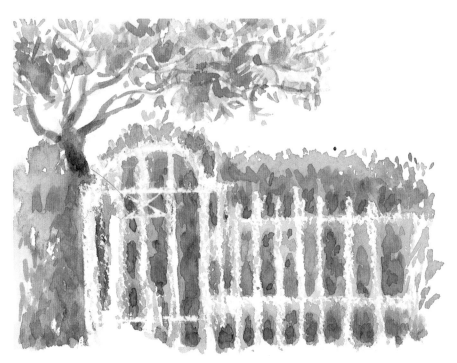

▲ *I used the pointed end of a candle to draw the gate and fence, then held my breath as I put on the green, hoping that the wax would resist in the right places. I rather liked the rough edges caused by the grain of the paper; the effect is quite different to masking fluid.*

Tips

● Masking fluid can be impossible to remove from Rough paper. It is best on a Not surface.

● Dried masking fluid can ruin brushes. Wash the brush in soapy water immediately after use.

● Crumpled cling film pressed into wet paint and allowed to dry creates an interesting marbled effect.

FLOWERS

A well-stocked garden in summer is composed of a huge variety of different shapes and colours. How you describe these will to some extent depend on the view you have chosen. For an overall panorama, you can often treat each bed or group of shrubs as broad areas of colour, but a close-up of one section will involve recognizable individual flowers, whose characteristics you will want to suggest – though without going into too much botanical detail.

BASIC SHAPES

In order to grasp the structure and form of plants it is helpful to make preliminary studies; this is where a sketchbook comes in handy. By looking closely at the basic shapes you will soon be able to separate them into categories. I have my own descriptions, which bear no relation to botanical names, but help me to simplify the forms. Trumpet shapes: daffodils and narcissus, orchids; foxglove, petunias, lilies. Circles: daisy family, dahlias, cornflowers, asters. Plume shapes: snapdragons, lupins, delphiniums, salvia. Cabbage shapes: roses, peonies, poppies, sweet peas, pansies, camellias. Florets: geraniums, phlox, achillea, sweet william, hydrangea. Architectural shapes: irises, tulips, crocuses, gladioli.

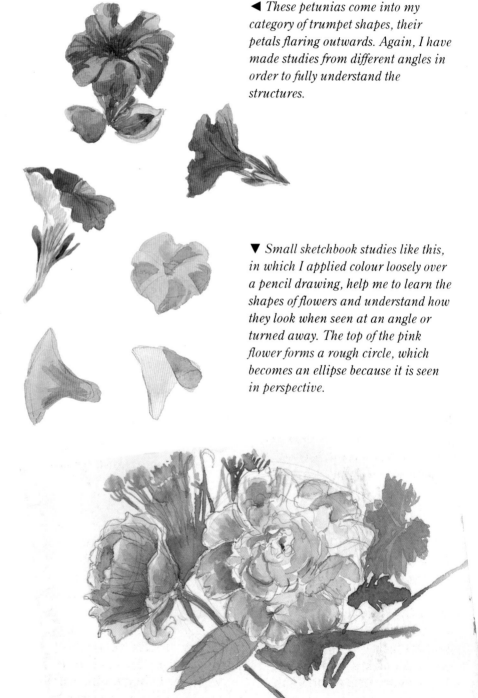

◀ *These petunias come into my category of trumpet shapes, their petals flaring outwards. Again, I have made studies from different angles in order to fully understand the structures.*

▼ *Small sketchbook studies like this, in which I applied colour loosely over a pencil drawing, help me to learn the shapes of flowers and understand how they look when seen at an angle or turned away. The top of the pink flower forms a rough circle, which becomes an ellipse because it is seen in perspective.*

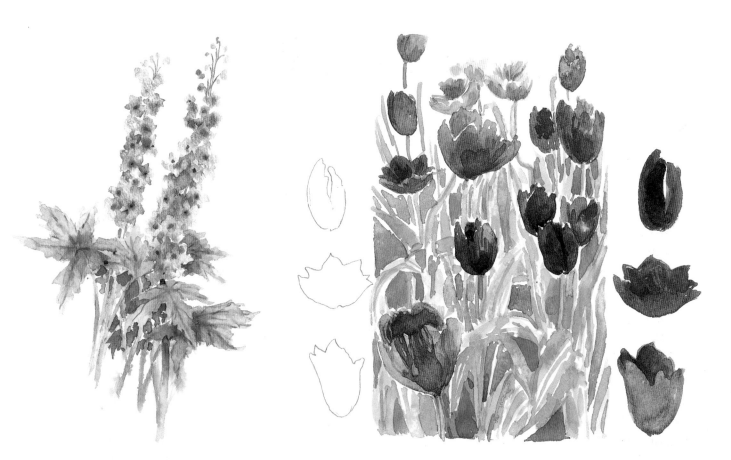

▲ *To paint a distant flower, letting the edges melt into the paper is the best solution, as this dissolves detail, giving a slightly blurred effect. This is a technique I call softening off. The delphiniums were painted straight onto slightly damp paper, then as the colour began to dry I worked into the centres with darker blue. An alternative method is to work on dry paper, but then use a damp brush to gently stroke the edges you want to soften.*

Tip

● In general, it is wise to avoid 'filling in' the stem and leaves of a flower and then adding the head. Instead, paint the whole in one fluid stroke, changing brushes for the different colours, or washing the brush quickly between colours. The flowers will appear less stiff, because you will have created the illusion of growth.

▲ *For crisp curved shapes such as these tulips you need to work on dry paper, using a brush which easily returns to a point. I used a No. 5 sable. Because the shapes settle so quickly I made sure of getting them right by sketching them out first. Then I painted in the shapes, left them to dry and built up with darker colour. Notice that the darker tulips have a tighter silhouette, while the others are more full-blown, allowing you to see into them.*

BRUSHMARKS

Once you have identified the shapes of the flowers, try to let your brushes help you describe them. There is always a danger of producing a rash of incoherent marks that resemble knitting, so practise making marks, using first just one brush and then your whole range, to see what they can do. The angle at which you hold the brush, the speed of working and the brush type are all factors, as is the personality of the painter. I am impatient and enjoy painting loose studies, so my brush strokes are often very immediate. But if you want to build up a painting gradually, aiming at some degree of detail and realism, a suitable procedure would be to begin with overall washes made with a large, soft round brush, finishing with a fine brush for details.

Developing fluid brush control takes practise but it is the key to painting both individual blooms and great swirling seas of flowers. Vary the marks, especially in a massed border, exaggerating the differences in pattern and outline. And to create the illusion of space, try to make your brush strokes smaller in the background and bigger and bolder in the foreground.

TREES AND SHRUBS

Trees and shrubs will often form a background to flowers, their greens, blue-greens and browns forming a useful colour contrast to the more vivid colours. But sometimes they may be the painting subject itself, for example in a landscaped park, or an early-summer garden featuring massed displays of rhododendrons, hebes and azaleas. In either case, you will need to pay careful attention to the overall shapes and sizes, and the colour of the foliage; if these are correctly observed you can often get away with little or no detail.

BASIC TYPES

Trees vary enormously in general shape and proportions, but the first characteristic to look for is the ratio of leaf canopy to trunk. For example, cypress trees are tall and thin, with the leafbearing branches extending only slightly outwards from the trunk, whereas the spreading branches of oak trees produce a wide, heavy leaf canopy – an oak can be almost as wide as it is tall. Look also for the way the branches grow out from the trunk and the way they are spaced: some slope downwards, some upwards, and some nearly at right angles, with regular intervals between.

Shrubs can be more easily categorized in terms of shape,

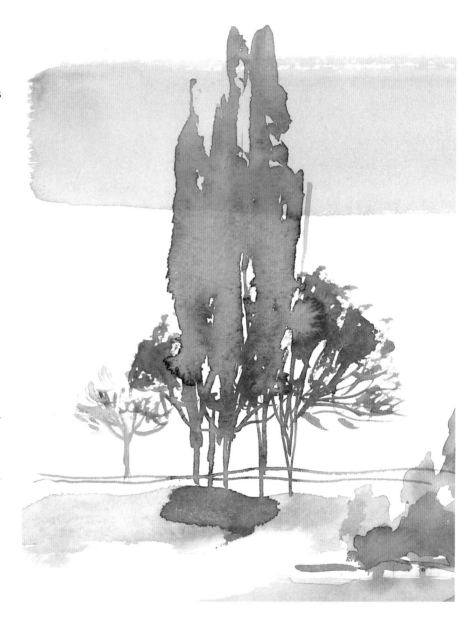

and I have created a personal list of types that is very similar to the one I use for flowers. Feathery: acer, lavender, heathers. Bushy, neat: rhododendron, hebe. Spiky: palms, ferns, bamboo, grasses, rushes. Arching, rambling and climbing: laburnum, wisteria, clematis, honeysuckle.

▲ *Trees seen against the sky are silhouetted, so I paid careful attention to the overall shapes, the irregular edges and the small, intriguingly shaped patches of sky seen through the foliage. Again I damped the paper in the foliage area so that the paint flowed outwards, stopping when it met dry paper so that the wash formed a distinct, slightly jagged edge.*

When in flower, of course, many of these shrubs will be recognized by the flower colour, but the overall shape and growth habit provide equally important visual clues.

PAINTING METHODS

Painting trees and shrubs gives you the chance to really go to town with your vocabulary of brush strokes. For arching and rambling shrubs, let your brush twist and wriggle; for bamboos or palms, try small tapering flicks with a pointed brush. The simple shapes of cypresses can be made with a single stroke of a round brush, easing pressure from the bottom to the top. Making the same mark the other way around – pressing at the top and lifting at the bottom – could suggest a very distant row of poplars. For the horizontal spreading pattern of a Scots pine, sweep the brush freely across the page.

To suggest broken textures such as the tiny, delicate leaves of silver birches glistening in the sun, try the dry-brush method, splaying out the hairs of a large, flat-ended brush and dragging dryish paint over the paper. This works very well on Rough paper, as the paint catches only on the raised grain.

For densely leaved shrubs, build up successive layers of dabs with a round brush, working both wet-into-wet and wet-on-dry. Or you can use a sponge as your painting tool. Press it into fairly dry paint and then apply lightly to the paper so that you have a mass of separate dot-like marks. You can build up the forms on your page with further layers of darker sponged colour.

▲ *This is a simple method for a full-foliaged tree shape. I began by wetting the paper in an uneven shape. When the water had settled but not dried, I loaded a brush first with yellow and then with blue, letting the colours flood into the damp areas and mix to form green. I finished with a small brush, giving structure to the image with an indication of branches.*

▲ *A small natural sponge is a useful piece of equipment and is ideal for foliage textures. I used Lemon Yellow and Prussian Blue to give a fresh impression. I progressed from the lighter to the darker colour, and the two mixed on the paper to form green.*

▲ *If a tree or shrub is in the foreground of your painting you will need to engage with it in enough detail for it to make visual sense. This does not mean painting every leaf; the key is to focus in on a few edges or groups of leaves, as I have done here. I laid a light-green wash for the tree, left it to dry and then took darker colour around the edges of the leaves.*

Tip

● The bushy type of shrub is densely packed with leaves, and can be painted initially as a simple shape, but avoid making the foliage of trees too heavy – there are always little gaps where the light shows through. Note the shape and position of these 'sky holes' and reserve them as pale colour when you lay washes for the trees.

LIGHT AND SHADE

Good paintings can be made on the dullest of days, but sunlight provides that extra ingredient. Not only are there areas of unexpectedly vivid colour where the sunlight falls; there are also patches of shadow, often colourful and interesting in themselves. The elusive, ever-shifting pattern of light is one of the major challenges to the amateur artist as well as the more experienced painter, but watercolour can cope with it, as it is the ideal medium for rapid impressions.

LIGHT AND COLOUR

Bright sunlight does not just intensify colours; it also changes them, and it does so in different ways according to the time of day. The 'local' (actual) colour of a rose may be soft yellow, but it will appear almost white under a harsh midday sun, while in the late evening, when the light often has a golden glow, it may look much nearer to orange than yellow. The shadows will alter also, becoming longer and often more colourful, with a purplish tinge, when the sun is low in the sky.

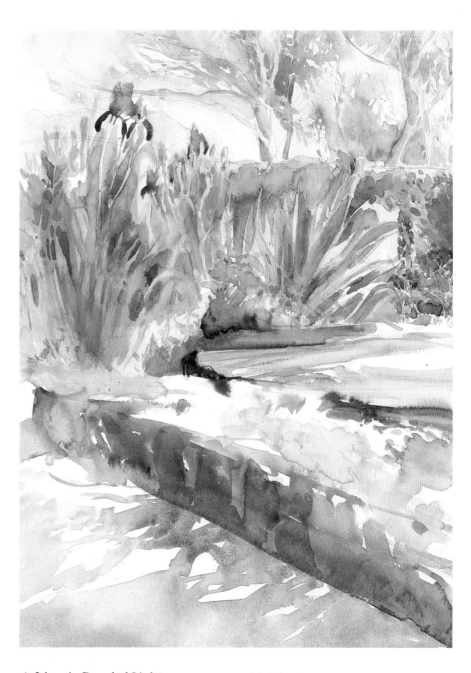

▲ Irises in Dappled Light
49.5 × 33.5 cm (19½ × 13¼ in)
This painting was done on a soft-lit, moist early-summer afternoon, and I wanted to convey the mood of the shady enclosed garden. To help me think in these terms I focused on the way the shadows melted and blended rather than placing emphasis on the actual flowers. To keep the colours and tones soft and muted, I used a limited palette.

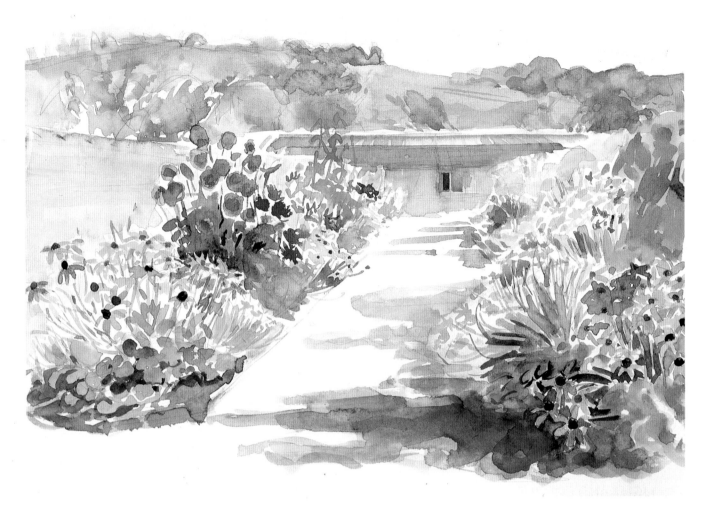

TONAL CONTRASTS

A bright day will show up extremes of contrast between light and dark, and if you want to emphasize this, you can leave areas of pure white paper. This may not be accurate because you seldom see pure white in nature, but it adds to the sense of light, and avoids having to make the shadows too dark and heavy.

To reserve these white areas you will need to plan ahead and decide which parts are to be left before you pick up your brush. If you find it difficult to paint around highlight shapes, make a light pencil drawing as a guide and stop out the shapes with masking fluid (see page 20).

Next you have to think about the darkest areas of the picture – the shadows. In very bright weather conditions there are few in-between tones – you are dealing with extremes – so to point up the bleached-out colours in the brightly lit areas, make the shadows look strong and pronounced. Using a blue-grey rather than a watered black or brownish-grey works best.

TONE AND FORM

One of the tasks of the painter is that of creating the illusion of three dimensions on a flat piece of paper, and you cannot do this unless you correctly observe the effects of light. The form of any object is modelled by the way the light strikes it, creating a pattern of light, dark and midtones.

▲ West Dean Garden
25.5 × 33 cm (10 × 13 in)
This quick sketch was painted in early September in a garden principally planted in warm yellows, reds and oranges. The time was late afternoon, as can be seen from the length of the cool bluish shadows. I left the path mainly white, and also left some chinks of white between clumps of flowers to indicate how bright the light was. I had to paint rapidly to capture the light, so I worked on a small pad of Hot-pressed (smooth) paper, which is easier to cover quickly than a Not or Rough surface.

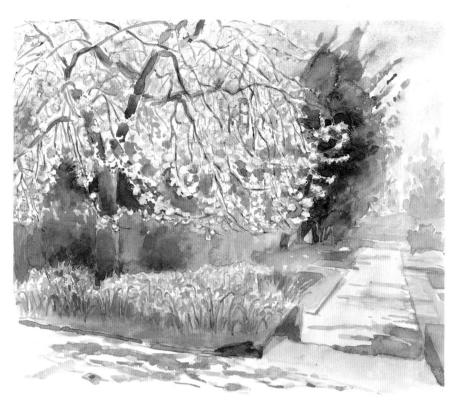

◄ Waterlow Park
30.5 × 37.5 cm (12 × 14¾ in)
This scene was painted in two hours one afternoon in spring. The subject contained all the right ingredients: a dense bed of daffodils with a dark hedge behind for contrast, a blossom tree, and a path to give depth to the composition. I masked out the blossom shapes, adding a touch of pink after removing the fluid. The most difficult part was to understand how the blossom passed in front of the trunk and branches; the overlap gives a convincing feeling of volume.

It can be difficult to judge these tonal values accurately, because colour 'gets in the way'. The word tone refers only to how light or dark a colour is, regardless of its hue. For example, Cobalt Blue and Indigo are both the same basic colour (blue), but Cobalt Blue is light in tone and Indigo dark.

But it is no good telling yourself that a certain colour is dark because that is its nature; its tone alters according to the amount of light present at any given moment, with a dark tree trunk becoming light when suffused with sunlight, so you must constantly assess the relative tones of each colour in the subject, asking yourself whether something is lighter or darker than that which stands next to it. This is much easier if you half-close your eyes, which reduces detail and cuts out the full effect of the colours. For practice, try making a tonal study in pencil or monochrome paint.

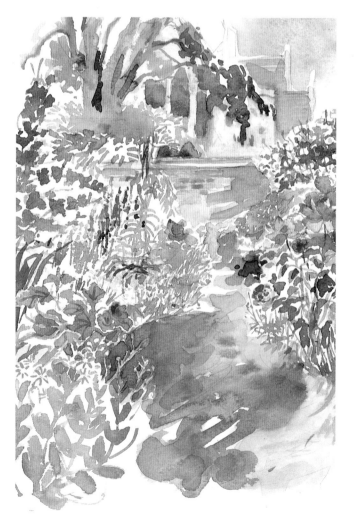

◄ Uri's Garden Border
30 × 22 cm (11¾ × 8¾ in)
Like the painting on the previous page, this uses the white of the paper alone to depict the sparkle of sunlight. Edges can catch the light to pick out the flowers, and I have represented these as a white line running around the shapes (notice the roses on the left). Although I was attempting a bold statement I gave thought to planning the painting sequence, particularly where to reserve paper for the highlights.

Tip

● To help you to judge a very dark tone, such as a tree trunk or deep shadow, hold up a black object such as a book in front of it. You will see that although it may be the darkest tone in your subject, it is it is nowhere near black.

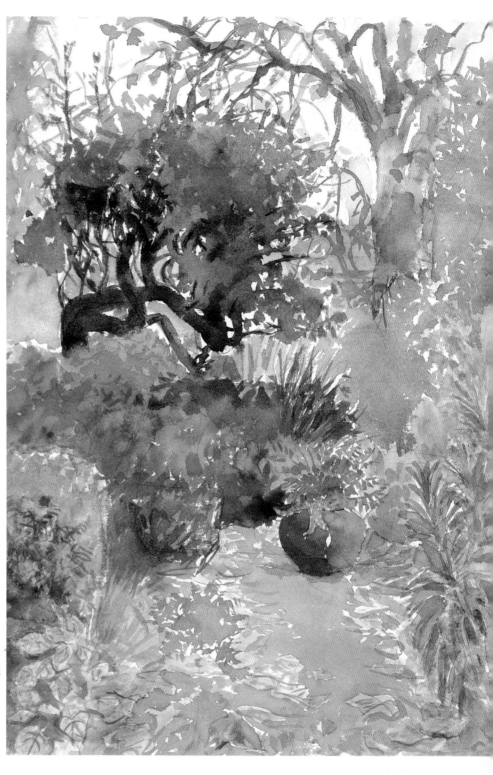

▲ Making a tone sketch serves two functions. First it is good practice in analysing tones, and second it helps you to consider the composition and balance of lights and darks before starting on the painting. Restrict yourself to five tones – very dark, dark, mid-tone, light and white paper – and hold back on the extremes of tone until you can judge where best to place them. You can do this kind of study in different grades of pencil (HB to 6B), making sure to use the minimum of line – the emphasis should be on shape and form. Alternatively, you could make a monochrome study in paint, using a range of washes from very pale to near-black.

▲ Autumn Garden
35.5 × 25.5 cm (14 × 10 in)
The tonal analysis was a great help in planning this subject, because I had already explored the possibilities of the viewpoint and composition. Notice how the tonal gradation on the pot defines its form, and also how the two darkest areas of tone – the left-hand tree and the pot – balance one another. Again, I have left white-paper highlights to suggest sunlight and to prevent the overall colour scheme becoming too sombre.

COMPOSING THE PICTURE

Deciding how to design your painting is not always easy, because there are usually a number of different possibilities. Your first choice is to decide on a viewpoint – will you take a broad view encompassing most of what you can see, or will you home in on some detail such as one flowerbed or group of shrubs?

CHOOSING THE VIEWPOINT

To help you make this first important decision, you will find a viewfinder invaluable. When you look at a scene in the normal way you tend to unconsciously pan around with your eyes, taking in more than will actually fit onto your paper, but with a viewfinder you can isolate various parts of it, just as you do when composing a photograph, so you have a better idea of how it will look on the paper.

The next decision is where you will paint from, and whether you will sit or stand. This is not just a matter of comfort; it also affects the composition, as your eye-level dictates where the horizon line is. Looking down from a high viewpoint gives you a high horizon, providing a broad panorama from foreground to distant features. This would be ideal for a broad view of a landscaped garden on several different levels, perhaps with ponds and a variety of separately planted areas.

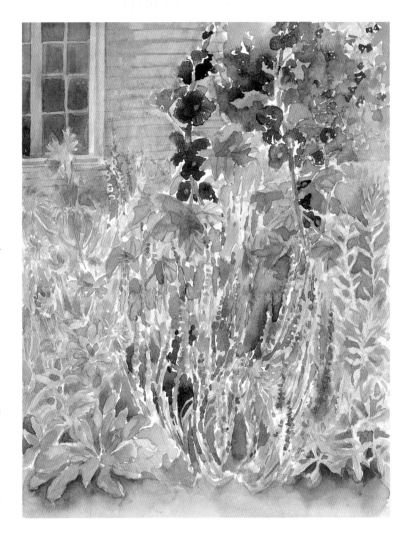

If you sit on the ground and look up, the horizon will be low, so you will see much more of the sky and any foreground features. A low viewpoint would be suitable for capturing details of tall plants, climbers, or a section across a border. If you are not quite sure where the horizon line is, hold up a pencil at arm's length in front of your eyes and see where it coincides with something in the scene.

▲ Hollyhocks
34 × 25.5 cm (13½ × 10 in)
The choice of whether to take a close or distant view will often be made for you by the subject itself. Going further away to include more foreground or background would have reduced the impact of this dramatic border. I chose a low eye-level to make the most of the way the flowers reach towards the sky, and allowed the hollyhocks to go out of the picture at the top, stressing their height.

▶ A viewfinder is easy to make, simply by cutting a rectangular aperture out of a piece of cardboard. To decide whether to take a close or distant view, try it out at different distances from your eye. By holding it out at arm's length, for example, you can cut out the foreground and focus on a small part of the middleground. The viewfinder will help you decide on a format too – hold it first horizontally and then vertically to see whether a 'landscape' or 'portrait' shape will best suit the subject.

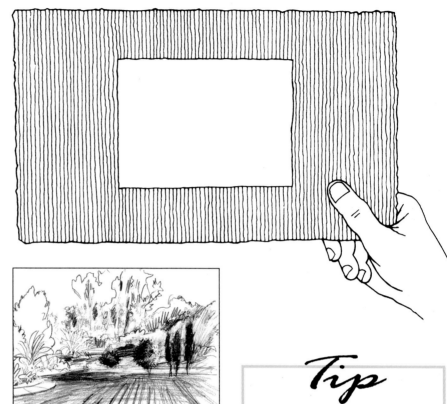

▶ This broad view takes a wide section of the garden, with the shrubs in the middle distance providing a focal point and the expanse of grass together with the tall background trees defining the space and scale.

Tip

● If the centre of interest is in the middleground, don't clutter the foreground with too much detail. Leave it vague, with suggestions of grass or flowers.

▶ Here I have homed in on a small section of a typically planted border. The conifer provides some compositional structure; the rest is a mass of various shapes. The challenge would be to define these in some way without becoming too bogged down in detail.

▶ Remember when you are making your drawing that because your eyes dictate the position of the horizon it will move if you do. The diagonal lines made by receding parallel lines will slope more sharply when you sit than when you stand, because the horizon line is lower. Perspective is more than just a set of tiresome rules to make your head ache; it can also help you compose your picture. Try looking at the subject from both high and low viewpoints and see how things change. But don't start a drawing standing up and then sit down, or you will get into a serious muddle.

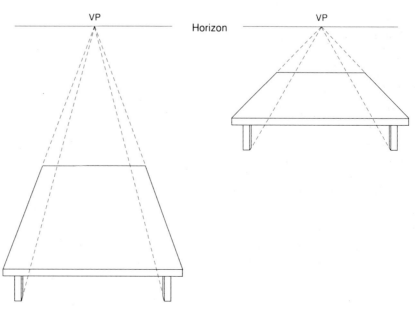

PLANNING THE PICTURE

Choosing the viewpoint is the first step in composing the picture, but there are other considerations too. There are few hard and fast rules about composition – and as soon as rules are formulated, artists tend to enjoy breaking them – but there are some general principles which you may find useful to bear in mind.

Try not to divide the rectangle of your picture area into equal parts; over-symmetry in a painting makes for a dull and static composition. So first find the centre and avoid it – don't put the focal point there. A focal point is the picture's centre of interest, which is usually what you yourself find most interesting and want to draw attention to.

The rule of asymetry also applies to sky and ground. If you have chosen a viewpoint which shows a lot of sky, don't give it the same amount of space as the ground –, again, find the centre and avoid it.

A good painting is not just an assemblage of different components; all the elements in a composition should be linked to each other, so try to unify your picture by creating echoes, repeating colours and shapes from one area to another. You also want to create a sense of 'movement' in your composition, so that the viewer's eye is led into and round the picture. You can often do this by providing lead-in lines from foreground to middleground, such as paths, fences or lines of pots. The eye naturally follows lines, so these act as a kind of signpost to the focal point, but be careful to make them point into the picture not out of it.

SPACE AND DEPTH

You will find it much easier to convey space in your painting if you think of it as having three distinct areas, or 'planes': fore- middle- and background. The colours of foreground flowers will be bright and clear, with strong contrasts of tone that pick out all the details very clearly. The colours gradually weaken towards the background, becoming bluer or greyer, with contrasts of tone and detail progressively diminishing.

▲ Peter's Norfolk Garden
25 × 30.5 cm (9¾ × 12 in)
I began with a rapid pencil sketch to establish proportions and help me decide how much of the wall to put in – sitting further away was a possibility. It is a good idea to work out the composition in this way before committing yourself in paint; a few scribbled lines will often clarify your thoughts. The diagonal line of the wall is a good natural lead-in, and the fork is vital foreground interest. Try cutting it out by putting your finger over it and you will see how the composition suffers.

A common mistake is to use a bright red or blue for background flowers because you know it to be their actual colour; this destoys the sense of space, as bright colours advance to the front of the picture. So keep your tones and colours lighter towards the back of the picture. In watercolour work you always begin with pale colours in any case, so start with the background and work forwards, strengthening the colours and tones as you go.

Help yourself to create space by observing the effects of perspective. Objects become smaller as they recede, so a distant wall, pergola or other garden feature may be half the size as one in the foreground or middleground. Everyone knows this basic rule of perspective, but is surprisingly easy to get the scale of things wrong.

Another way of suggesting spatial depth is to let objects – flowers, bushes, tubs and so on – overlap one another. This helps the composition too, as it creates relationships between them and makes the scene look natural.

▲ Lucy's Garden
24 × 17.5 cm (9½ × 7 in)
This was painted from a window, and the unusually high viewpoint gives a strong feeling of space. You can see the whole length of the garden, with the path leading to unknown distance. The vertical format suited the subject, giving me a chance to exploit the verticals and diagonals that hold the composition together. The tall tree in the foreground – appearing taller because it goes out of the picture – contrasts with the smaller shrubs to give a sense of scale.

CHOOSING A SUBJECT

Gardens may seem a small subject area in which to specialize, but actually it is a very broad one in comparison with, say, portrait painting, which is restricted to faces. There are many different types of garden, from grand formal affairs to small cottage gardens crammed with flowers that appear to have taken root of their own choice, added to which they all look different according to the season and weather conditions. You could paint the same garden over and over again and never repeat yourself. Monet made countless paintings of his own garden from different viewpoints and under different light conditions, and many other artists have exploited this theme of 'series' paintings.

And if you stretch the definition of the word 'garden', you can include all sorts of things, such as a corner of a neighbour's vegetable patch, with neat rows and tools casually flung down; an allotment garden; flowerpots on a balcony; plants in a conservatory; a corner of the greenhouse with stacked terracotta pots and an uncurled hose – the possibilities are endless.

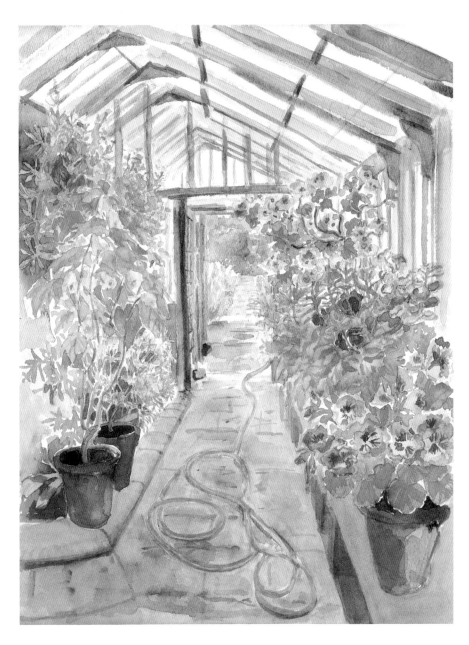

▲ Greenhouse
40.5 × 30.5 cm (16 × 12 in)
I was attracted to this subject by the striking display of pelargoniums, but then the hose caught my eye, and I realized that it played a vital part in the composition. It leads the viewer's eye right into the painting; without it the composition would have stopped dead in the foreground. This is a lesson in deciding how to use what is there to best advantage rather than leaving it out because it looks out of place or untidy.

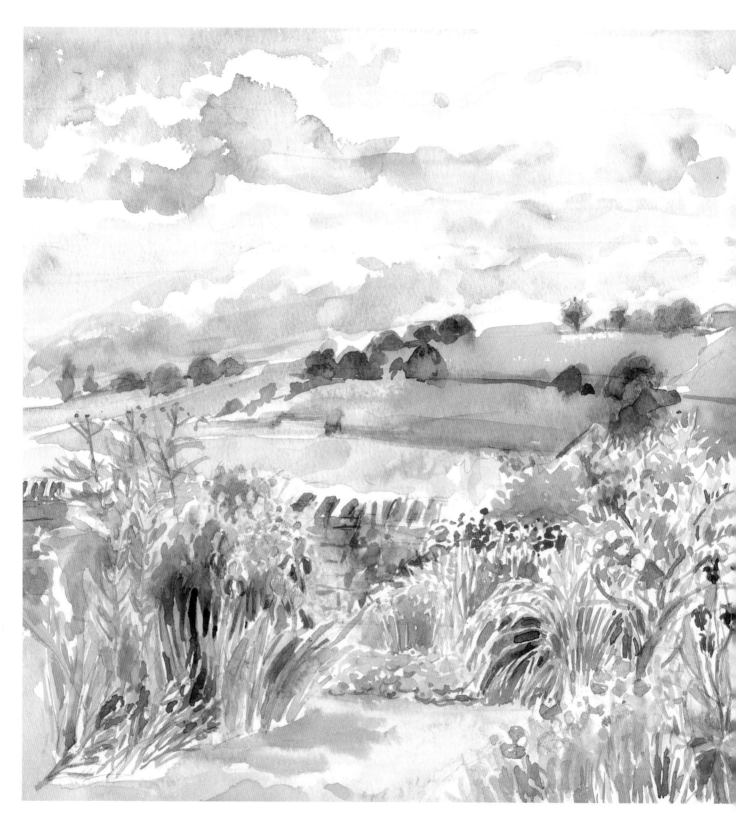

▲ Country Garden
31 × 30.5 cm (12¼ × 12 in)
On this occasion I wanted a complete change from a 'manicured' garden, and found a perfect broad view, looking over an informal garden to open countryside and sky. The triangular shape of the wall in the centre provides a focal point and gives cohesion to the rather busy foreground area as well as marking the boundary of the garden area. The painting was done on a very bright day, so I left white-paper gaps intentionally to stress the shafts of light.

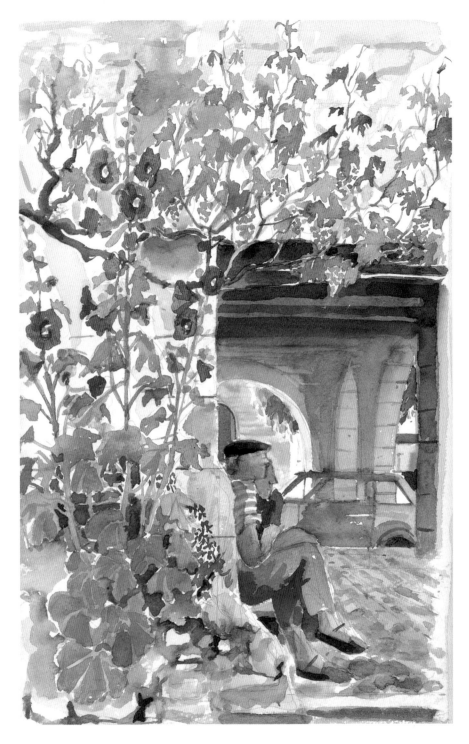

► Vegetable Garden
42 × 59 cm (16½ × 23¼ in)
I chose a high viewpoint for this vegetable garden, giving me a good overall view of the pattern made by the rows, and to punctuate the rather relentless greens I exaggerated the blueness of the cabbages. It is always worth exploring different viewpoints, and for a later painting I sat on the ground; by then the light had changed and there were more deep darks to differentiate the various forms.

▲ Frenchman with Hollyhocks
38 × 24.5 cm (15 × 9¾ in)
A trip to France gave me an hour in which to watch and paint this typical villager surrounded by his hollyhocks. I liked the casual way the plants grew out of the wall, and the contrast between the blue clothing and the red flowers. The man's seated position was important to the composition, as

it provided a perfect focal point, so I took several photographs of him – with permission – in case he moved away before I could complete the picture.

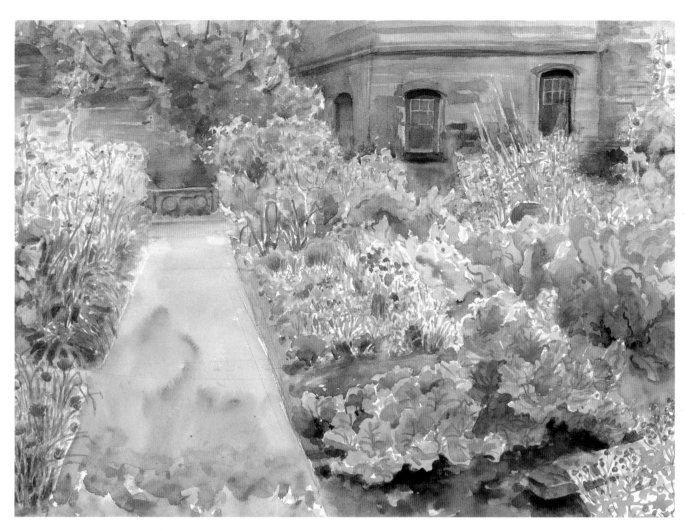

▶ Sally's Garden

40.5 × 51 cm (16 × 20 in)

This painting started out by being chiefy about the roses, but I saw that by including the summerhouse I could go further into the picture plane and create a sense of space. To help the background recede, I used cool, diluted colours, against which the brilliant pinks and purples of the foreground flowers (Permanent Rose and Cobalt Violet) stand out strongly.

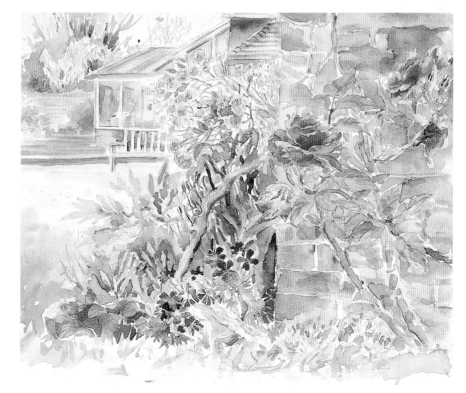

Holidays offer up a wealth of scenes, and because they are unfamiliar you will be particularly receptive to them. You may not always be able to sit down and complete paintings on the spot, but you can always take photographs, and there is usually time for quick sketches, so take a small sketchbook wherever you go so that you can note down possible ideas for paintings. In the winter months, when outdoor painting is not practical – and gardens are scarcely at their best – you can thumb through your store of visual reference and cheer yourself up by recreating summer in your paintings.

◀ *These quick studies of a flower show were done in a small sketchbook (Daler Langton size 178 × 127 mm/ 7 × 5 in). In the first sketch I was particularly drawn to the way the dark foreground objects and the blue clothing of the figure contrasted with the brilliant reds of the flowers.*

WORKING FROM PHOTOGRAPHS

Although there is still a slight feeling that painting from photographs is in some way cheating, most artists do make use of the camera in this way, and for beginners it is a gentle way in, giving you the chance to build up your skills so that you have confidence when you make the leap to outdoor painting. But it is best to use photographs as a starting point rather than trying to produce an exact copy.

I recommend taking a selection of photographs and working from these combined with sketches, as this gives you more leeway to interpret. I often take photographs at the same time as painting, as a kind of insurance policy. A figure may move before I have finished, or the light may change – it usually does. I keep the photographs as

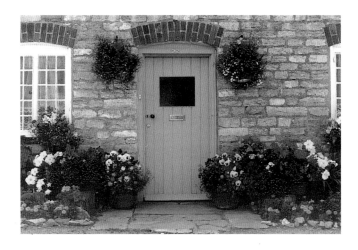
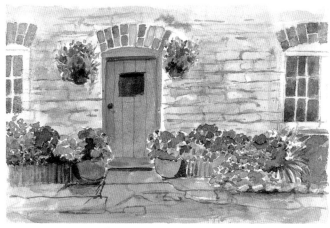

▲ *I was very excited by this cottage front, with the vivid blue door, hanging baskets and tubs crammed with summer flowers, but had no time to paint, so took a photograph to work from. I make few changes in the* *painting, as the image was straightforward, but I moved the windows and door to avoid an over-symmetrical composition, and made slightly more of the front border.*

▼ *By collaging several photographs together you can create a complete gardenscape, giving you more sense of place than a perfectly composed and well-focused photograph of a single section. Of course, there will be incongruities of scale, and sometimes the colours won't match perfectly, but a 'hotchpotch' like this can be an inspiring basis for a painting.*

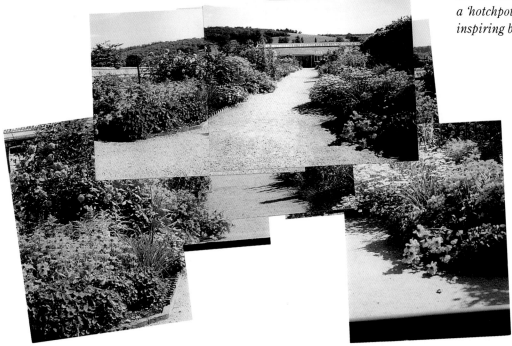

reference, so that if the painting on the spot has failed through overworking, or perhaps I have not had time to finish it, I have both photographs and painting as information, enabling me to try again.

If you have decided to work from photographs alone, you will give yourself a greater overall feeling of your subject matter if you take several shots of the surrounding area as well as the particular part of the garden in which you are interested. Alternatively, there is an inexpensive 'throwaway' camera you can buy which takes 'stretched' photographs (an area covering three normal-sized prints). I use one of these when recording a walled garden.

WOODLAND GARDEN
DEMONSTRATION

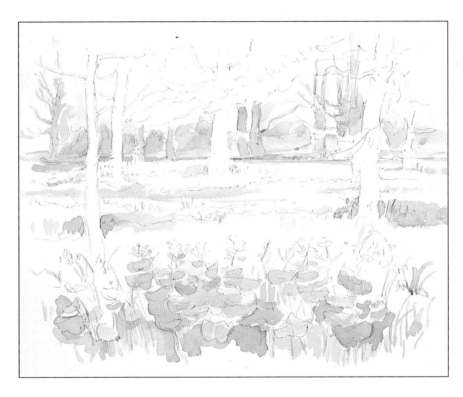

◄ *First stage*

Many public and private-house gardens open to the public have woodland areas where the natural flora is allowed to grow wild. This was one such, presenting a lovely subject in early spring, with the lemony-green foliage contrasting with the soft mauve-blue of the bluebells. I was aware of having to keep a light touch throughout the painting in order not to lose the fresh luminosity of the colours. I had already planned the composition, visiting the scene earlier to make preliminary studies, so I did not need to waste valuable painting time deciding on a viewpoint. The painting took two and a half hours, and was done on Not surface paper,

300 gsm (140 lbs), and I used three brushes, Nos. 3, 5 and 8.

COLOURS
Cadmium Lemon Yellow; Cobalt Violet; Ultramarine; Prussian Blue; Emerald Green; Permanent Rose; Burnt Sienna; Vandyke Brown.

FIRST STAGE
I lightly drew the image in pencil, working very broadly to avoid 'filling in' drawn shapes with paint. I always keep the preliminary drawing loose, as I like to be open to noticing new things and making changes as I work. I then painted the distant tree trunks, using a weak mixture of mainly Cobalt Violet

and Vandyke Brown. The bluish-green background foliage – a diluted mixture of Cadmium Lemon Yellow and Prussian Blue – came next, and then a light suggestion of greens in the middleground and foreground. For the broader shapes I used the No. 8 brush, and for the grasses the No. 5.

SECOND STAGE
The next step was to paint the middleground trees. I used Burnt Sienna for the trunks, pulling out the branches with the fine (No. 3) brush. Thin washes of the green used for the background established the foliage, with additional yellow at the top to create a sunlit effect. I then

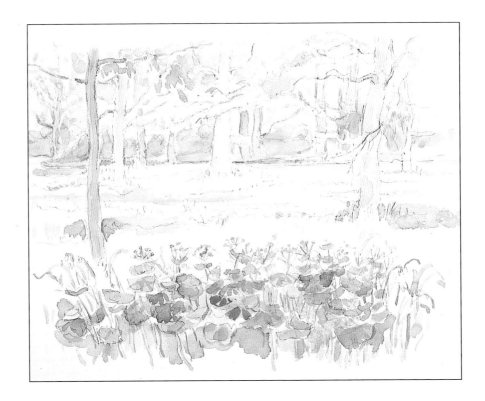

◀ *Second stage*

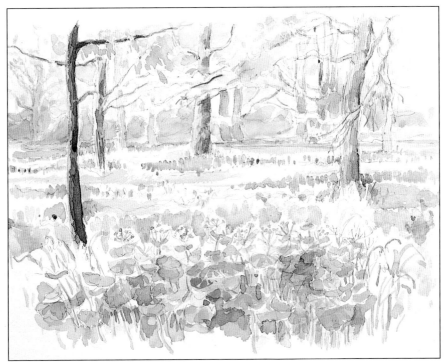

◀ *Third stage*

strengthened the foreground with Emerald Green and a stronger application of Cadmium Lemon Yellow. I resisted the temptation to begin on the flowers until I had provided a framework for them and could judge one colour against another.

THIRD STAGE
Now I had my reward for patience, and was able to start on the bluebells. I began with a fairly diluted mix of Cobalt Violet and Ultramarine, taking care to make the brushmarks diminish in size from the front to the back of the

picture to suggest the receding planes. Notice that because I also used Cobalt Violet for the distant tree trunks, there is a colour relationship between the two areas; this was why it was important to begin with the background.

FINISHED STAGE

When the paper is covered, with all the colours in place, you can assess the picture and see what still needs to be done. This is the most enjoyable stage of the painting, but care has to be taken not to overwork. The key is to build up sensitively, making marks that help to define the forms but not covering existing painted shapes, which can cause muddy colours and loss of transparency. I modelled the trees with broken lines of Vandyke Brown, leaving the sunlit side as the original pale colour, and then worked into the bluebells with varying intensities of an Ultramarine, Cobalt Violet and Permanent Rose mixture. In the centre of the picture I created a subtle focal point by picking out the stems and heads of a clump of bluebells with the fine brush.

▶ *Finished stage*
The First Bluebells
30.5 × 40.5 cm (12 × 16 in)

FORMAL GARDEN
DEMONSTRATION

In many of the country-house gardens open to the public there are interesting architectural features such as flights of steps, walls and balustrades, as well as ornamental urns, benches and statuary, all of which give a painting an extra element and provide a structure to the composition. Because this painting was more about the formality of the garden than what was growing in it, I chose a corner that contained these features, focusing on the general form of the garden; there would be little point in choosing a single detail in a garden like this. I worked on Hot-pressed paper, 300 gsm (140 lbs) and used only two brushes, Nos. 6 and 12.

COLOURS
Cadmium Yellow; Raw Sienna; Indian Red; Cadmium Red; Cobalt Blue; Prussian Blue; Winsor Green; Hooker's Green.

FIRST STAGE
I began with a pencil drawing, using fairly free, lightly-scribbled lines, but making sure the general shapes and proportions were correct. The bench in the foreground was particularly important to the composition, and I took care over the perspective of the circles. For the first washes, for the walls, urns and shadows, put on with the large brush, I mixed a warmish neutral – Indian Red and Cobalt Blue used in different dilutions. For the cool colour of the cypresses I added Winsor Green to this mixture.

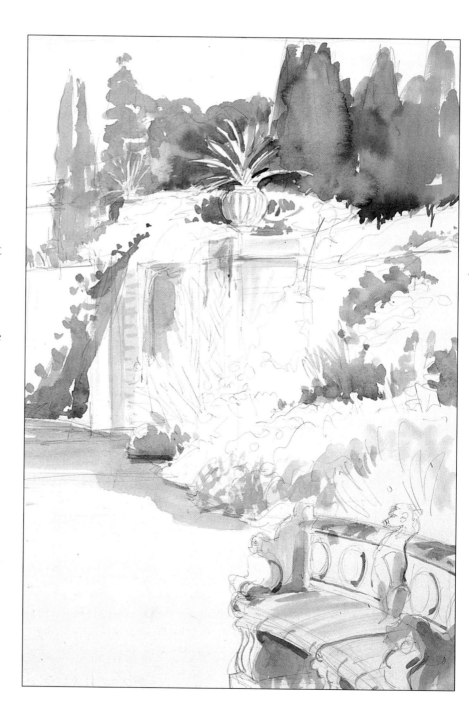

▲ *First stage*

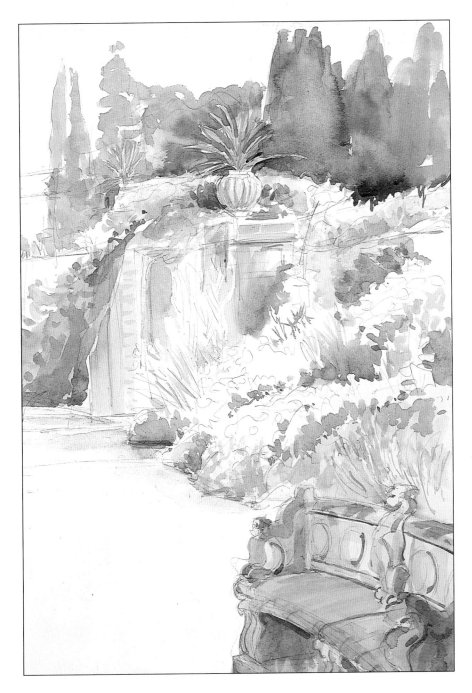

▲ Second stage

SECOND STAGE

I saw the warm/cool contrasts as important from the outset, so I fortified the warm colours in the wall, path and bench with Indian Red and a little Cadmium Red. These reds are very strong, so I diluted them quite heavily. I then began to build up the details of the carving, using the same purplish-grey mix as before, and finally started on the areas of planting. Here I needed some firm delineation but a subtle range of greens, so I used the No. 6 brush to give fine brush lines, and mixes made from Hooker's Green and Cadmium Yellow, and Hooker's Green and Cobalt Blue.

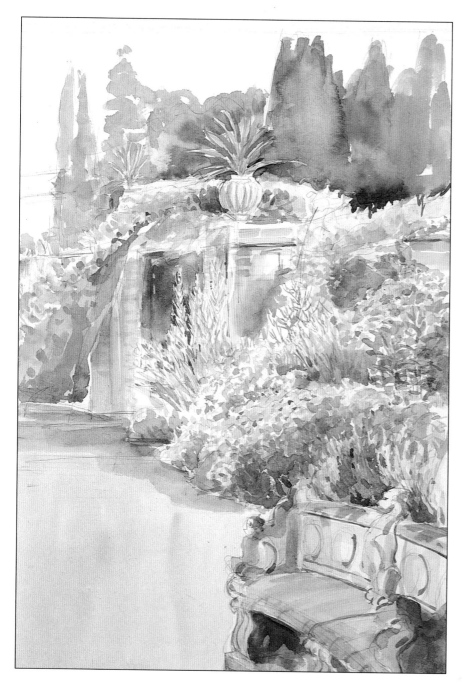

▲ *Third stage*

FINISHED STAGE

The final stage was to put the real darks into the distant trees, under the bench, and at the base of the border behind the bench. These brought everything into sharper focus, and increased the sense of space by pulling the bench forward. With these dark tones in place I was able to assess the overall balance of the painting, and saw that the colour of the path needed strengthening. I laid a light wash of Raw Sienna over it, encouraging small puddles to form, suggesting texture. Hot-pressed paper is particularly suited to such 'deliberate accidents', as the paint tends to slide about. You can see the puddling effect clearly in the background trees.

▲ *Detail of finished stage*

THIRD STAGE

This stage established the main differences of shape between the plants – some leaves feathery and others spiky, contrasting with the chunky oval flower heads. I continued to use the small brush, working carefully but restraining myself from an over-detailed approach.

▶ *Finished stage*
Blickling Hall
45.5 × 30.5 cm (18 × 12 in)

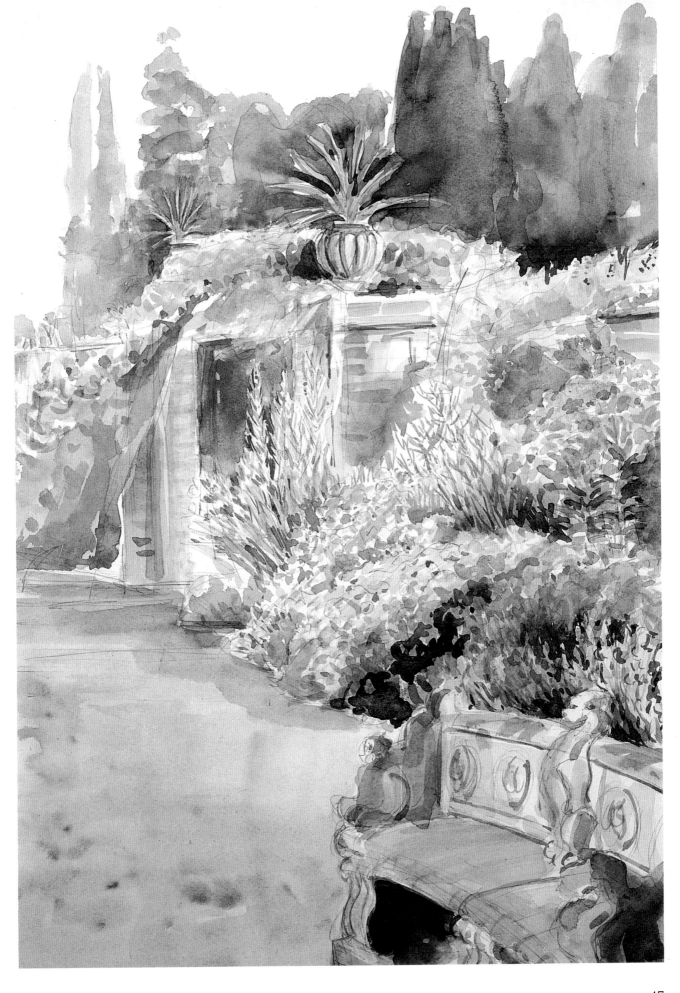

TOWN GARDEN
DEMONSTRATION

This colourful display – conveniently around the corner from my home – was irresistible, but I had to take care with the composition, balancing the architectural detail with the complicated arrangement of pots and plants. It was important to avoid the two elements fighting for attention, but at the same time I needed to create a sense of place by giving an accurate description of the building. I kept the treatment relaxed, however, suggesting the brickwork with broad brush strokes, and reserving detail and bright colour for the flowers. The painting took three and a half hours, and was painted on Not surface paper, 300 gsm (140 lbs). I used three brushes: Nos. 3, 5 and 10.

COLOURS
Burnt Sienna; Payne's Grey; Alizarin Crimson; Rose Doré; Sap Green; Hooker's Green; Prussian Blue; Ultramarine; Sepia; Cadmium Red; Cadmium Yellow.

FIRST STAGE
I took longer than I usually do over the drawing of the building (made with a 2B pencil), because I wanted to represent the straight lines of the facade and the structural details accurately; these acted as a perfect foil for the jumbled profusion of the flowers. The latter were drawn as very simple shapes because I planned to define the details in the final stages. With the drawing complete, I painted the walls with a dilute wash of Burnt Sienna, reserving the window and door shapes. I used a No. 10 brush for this, and the same brush

▲ *First stage*

for the light suggestion of the steps, made with a wash of Payne's Grey.

SECOND STAGE

Next I painted in the windows, again using Payne's Grey, and reserving areas of paper that were to remain white or paler in colour – sills, window bars, letter box and so on. To keep the colour scheme simple and unified, I used the same grey for the railings, bicycle and the shadows cast by the pots. Payne's Grey is an excellent 'all round' colour, useful in mixes and ideal for shadows, as it has a bluish tinge.

By this time the first layer of colour for the building had dried, so I was able to work over it, using another wash of the same colour and a No. 5 brush to suggest the brickwork.

▲ *Second stage*

was really able to put in the punch. For the flowers, I used dabs of colour almost as punctuation marks, restraining myself from too much accuracy, and leaving white paper in places to give a sparkle. For the flowers on the right I worked wet-into-wet, damping the gaps I had left between clumps of foliage and applying reds, purples and pinks which blended together. When these had dried, I added details (but economically), such as the stripes on a petunia. Finally, I darkened the shadows, particularly the one under the porch, for which I used a stripe of Sepia, wetting the edge with clean water to soften it. A tiny touch of Alizarin Crimson in the windows suggests curtains, and unifies the picture by making a colour link with the flowers.

THIRD STAGE

I then began to put the greens in, giving careful consideration to the variations in the leaf patterns so that I could make the brushmarks distinctive and convincing. I varied the greens also, first analysing how warm or cool each one was. The climbing plant, for example, is a cool green, and for this I chose Hooker's Green with a touch of Prussian Blue. Sap Green, used elsewhere, both on its own and in

▲ *Third stage*

mixtures, is a yellower, more vivid green, and the two stand out well from each other. Gaps of white paper were left wherever the flowers were to go, so that the later pinks and reds would remain pure and clean.

FINISHED STAGE

The final stages, as so often in watercolour work, were the most enjoyable, and it was here that I

▶ *Finished stage*
Floral Steps
61 × 40.5 cm (24 × 16 in)

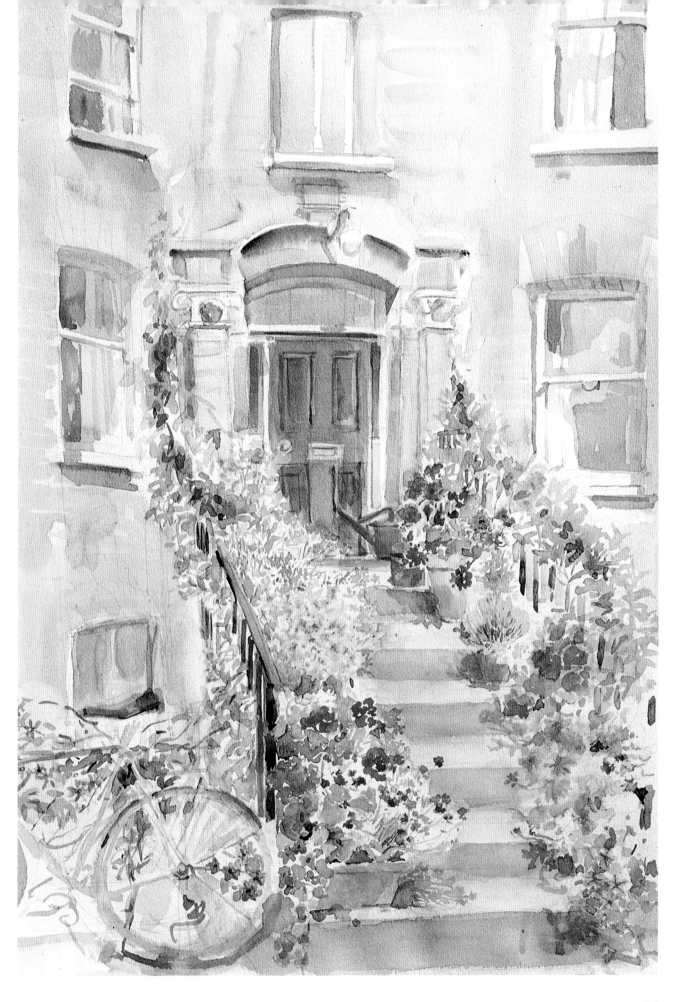

SUMMER BORDER
DEMONSTRATION

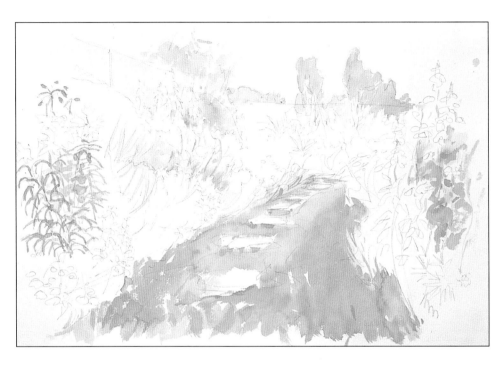

◀ *First stage*

This, painted on a perfect summer's day in the garden of a friend, represents perhaps the most difficult of all garden subjects. There is a great deal going on in a scene like this, and all of it enticing, but making sense of it in compositional terms is not easy. In a formal garden there may be statuary, a fountain, or a dramatic shrub that provides a natural focal point, and perhaps a wall that makes a good background, but here there was no obvious element to give structure to the picture. I decided to solve this problem by emphasizing the sweep of the path-like lawn, so that the composition works as a set of long curves and diagonals. The distant tall trees, although small, are important, as they act as a block to prevent the viewer's eye wandering along the lawn and straight out of the picture. I wanted some texture on the grass, so I worked on Rough paper, 300 gsm (140 lbs) and used two brushes, Nos. 6 and 12.

COLOURS
Hooker's Green; Cobalt Blue; Prussian Blue; Cerulean Blue; Payne's Grey; Permanent Rose; Cadmium Red; Alizarin Crimson; Indian Red; Cadmium Yellow; Lemon Yellow.

FIRST STAGE
I began with the lawn, using the large brush to lay a deliberately uneven wash in a mixture of Hooker's Green and Cobalt Blue. The roughness of the paper made the brushmarks show more obviously, suggesting texture. While the paint was still damp, I added tiny touches of Payne's Grey to suggest the edges of the paving stones. I then blocked in the distant trees with a bluer version of the same mix, and broadly positioned the lilies and snapdragons in the front of the picture.

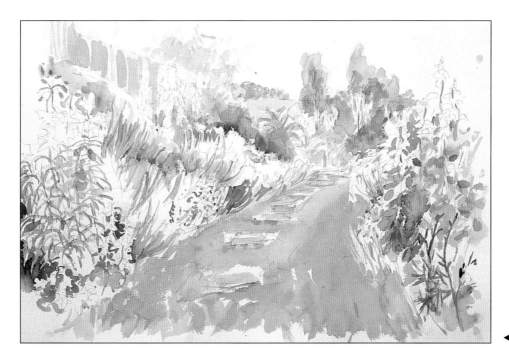

◄ Second stage

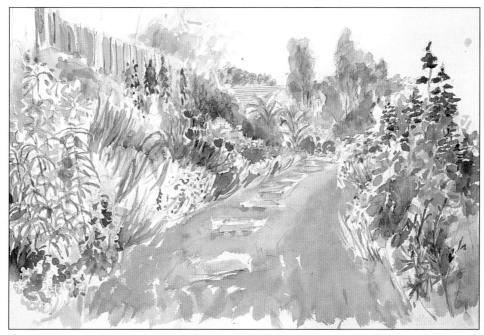

◄ Third stage

SECOND STAGE
A subject like this can easily become either over-detailed or too vague and amorphous, so I tried to make my brushmarks respond to the variety of shapes and growth patterns in the borders, leaving a good deal of white paper to give a feeling of movement and light. The greens were a mixture of Hooker's Green, Lemon Yellow and Cerulean Blue, with a little Indian Red and Prussian Blue added for the more neutral areas.

THIRD STAGE
This was the most exciting part. With the framework of greens established, I could put in the real colours. I began with those in the foreground, using Permanent Rose with a little Cadmium Red for the snapdragons, and Cadmium Yellow with a touch of Cadmium Red for the lilies. The blue surrounding the yellow works the complementary-colour trick, making them stand out strongly. The purples were all mixes of Cobalt Blue and Alizarin Crimson. Gradually, I moved back into the garden, cooling the colours and using less detail to preserve the sense of space.

FINISHED STAGE

If the third stage was the most exciting, the final one was the most challenging, because I had to be very careful not to overwork the painting. However, I clearly needed to do some further work on the nearer plants, bringing in some darker colour around the shapes to define the forms. Here and there I used Payne's Grey to 'force' a shape. I left the rest of the painting alone. If I had treated the lawn and paving stones in more detail it would have detracted from the effect of the border; as it is it makes a good contrast and provides a 'resting place' from so much busy activity.

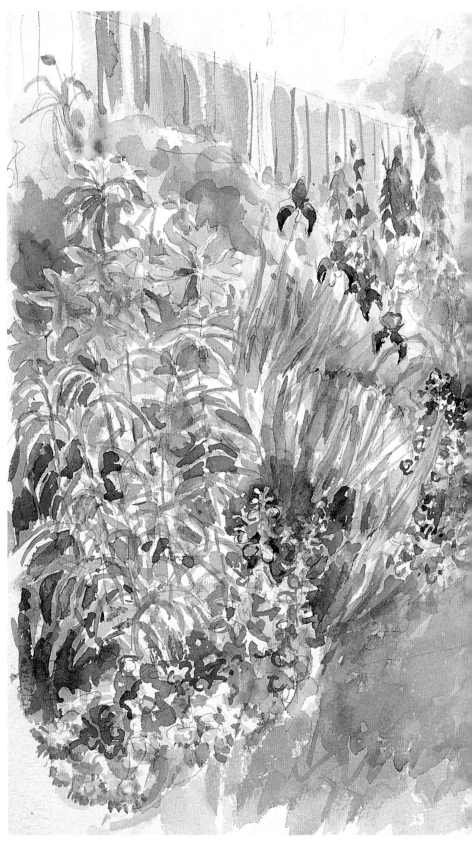

▲ *Detail of finished stage*

▲ *Finished stage*
Lynette's Border
45.5 × 51 cm (18 × 20 in)

54

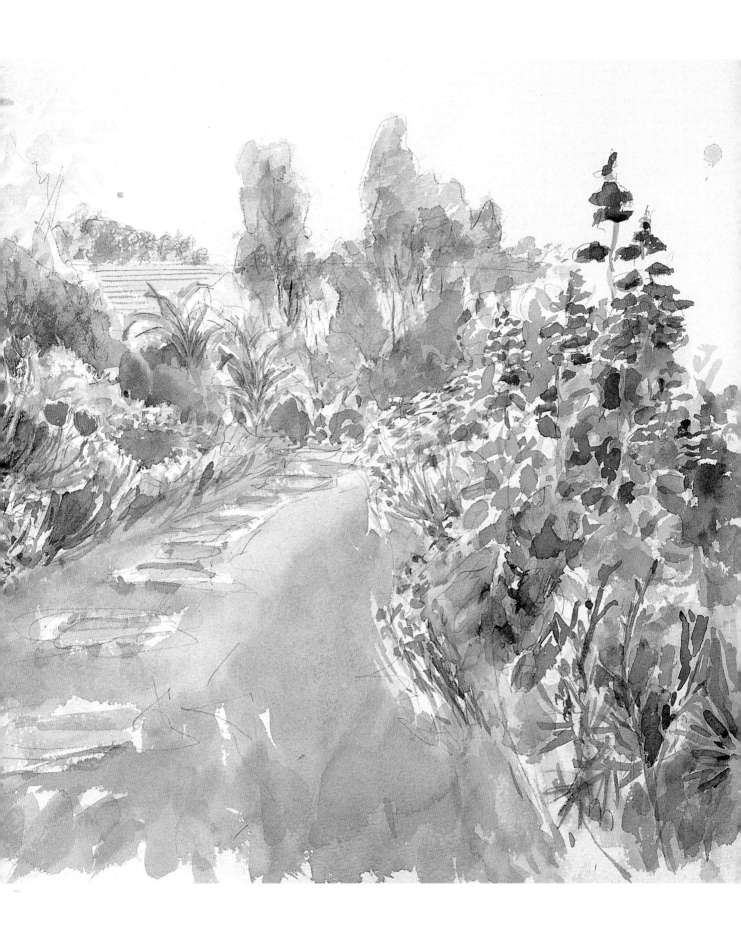

CONSERVATORIES AND PATIOS

We live in an overcrowded age. Many people have no space for gardens, so gardens have tended to come indoors, with warmth-loving plants housed in conservatories, and colourful annuals or evergreen shrubs attractively displayed on small patios. Both these make exciting painting subjects, with as many possibilities as large gardens. Indeed, they can be easier to manage in compositional terms because the man-made elements – walls, struts, window frames and paving stones – provide a geometric framework for the freer, more fragmented plant forms, and give a good touch of contrast. You could even change the emphasis of your painting, letting a pattern of floor tiles in a conservatory or the crazy paving in a patio dominate the picture.

▶ The Conservatory
35.5 × 25.5 cm (14 × 10 in)
The pattern of the tiled floor is the most important element in this painting, and I had to draw it very carefully in order to get the perspective right. If I had made the background tiles too big the room would have looked small; too small, and it would seem to stretch on forever. To make things a little easier, the edge of the table is parallel to the rows of tiles, and thus follows the same diagonal. After doing all this controlled work I enjoyed painting the foliage on the right wet-into-wet, allowing green paint to merge into yellow.

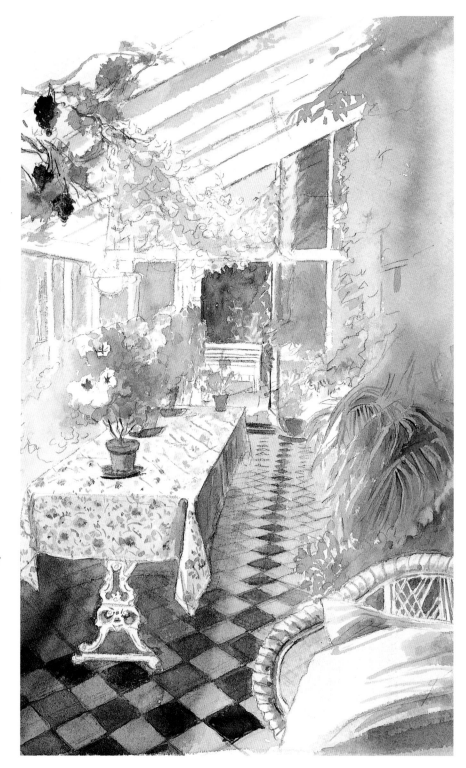

PERSPECTIVE

Architectural features and furniture, in the form of garden chairs and tables, plant tubs and ornamental containers, will play an important part in these semi-indoor subjects, and to depict them covincingly you will need to make a careful preliminary drawing, watching out for the effects of perspective.

As mentioned earlier, one rule of perspective is that things become smaller as they recede, so don't paint paving stones or floor tiles all the same size, or they will look like a wall rather than a flat plane. The other important rule of perspective is that parallel lines running away from you – the sides of a table, for example – appear to converge, until they finally meet at a point called the vanishing point. This point is on the horizon line, which, as you saw in the chapter on composition, is your own eye-level.

Don't become too obsessed with perspective, as this can be inhibiting, but do check the relative sizes of things and the angles of receding lines. There is an easy method for both these. To check the height of two flowerpots at different distances from you, hold your pencil out at arm's length and slide your thumb up and down it to take the measurement of one, then compare this with the other. You may be surprised at the result; it is a common mistake to make a background feature too large because you know its actual size.

For angles, adapt the method by tilting the pencil until it coincides with a line, for example, the side of a table or the bottom of a window. Then bring it back to the paper held at the same angle, and draw in the line.

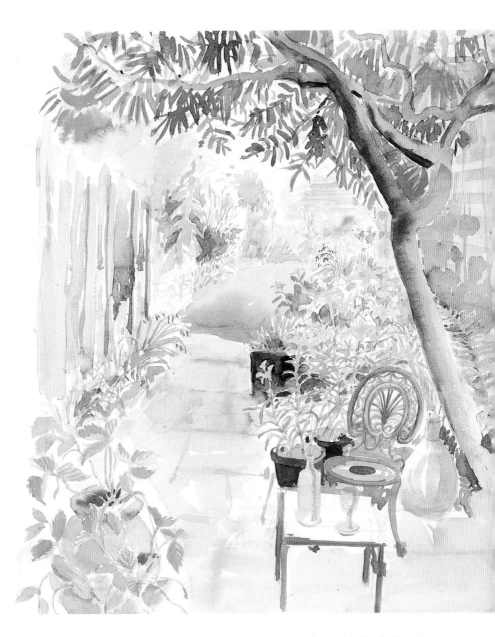

Tip

● Circles are altered by perspective just as straight lines are; they become oval shapes (ellipses), shallow if they are near your eye-level and more open if below it. If you hold up the top of a pot or bottle directly at eye-level you will only see a straight line.

▲ Uri's Garden, with Patio Furniture
40.5 × 30 cm (16 × 11¾ in)
My viewpoint was just above the patio, with the horizon line at roughly the top of the background lawn and the vanishing point in the middle of the picture. The sides of the buildings, the lines of the paving stones and the sides of the table all converge at this point. The circle formed by the pot and the top of the chair are also affected by the viewpoint. The painting was done on a hazy summer's day, which influenced my technique, in particular the soft blurring of the shadows on the tree trunk and the use of a graded wash for the lawn.

WALLS, ARCHES AND PERGOLAS

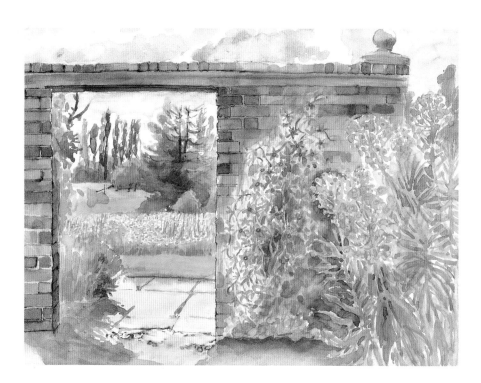

Artists often exploit the idea of looking through from one kind of space to another. Views from the inside of a room, with the window acting as a frame for the landscape outside, are a popular painting subject.

The snatched glimpse – a half open door with a hint of something going on beyond – is another theme that painters play on. Walls with doorways, gaps in hedges, gates and other more formal details such as pergolas and arches can frame unexpected views and draw attention to them.

Unless you have exceptionally wealthy friends you are unlikely to find such gardens unless you are visiting country houses, so whenever you do this, take your paints, or at least your

sketchbook and camera. Both of my paintings were done in well-known gardens open to the public, and you can buy guidebooks to gardens listing their special features.

DRAWING

With any subject that contains man-made features, you will need to be careful with your preliminary drawing, ensuring that the proportions are right, and that columns and so on are in correct perspective. In my painting opposite the lines of the columns and the wooden struts at the top form the skeleton structure of an elongated box shape, with all the parallel lines

▲ Denmans Gardens
30.5 × 40.5 cm (12 × 16 in)
This painting was done on a vist to a garden in West Sussex. As you can see, it was a sunny day, and the little vignetted view, with the foreground shadows making the yellow of the buttercups sing out, really caught my eye. The purple clematis behind the yellow-green euphorbia provided a lovely foreground, with the twisting shapes contrasting with the solidity of the wall. For the pen drawing, I chose an art pen, which gives a fine, unobtrusive line, and have used touches of line in the background and foreground as well as on the wall.

meeting at the same vanishing point somewhere outside the picture area.

If you have trouble with straight lines, don't be afraid to use a ruler. Avoid making hard, heavy lines on the paper, as these could show through your later washes. For a vertical, such as the side of a wall, either rule a very light line or measure from the edge of the paper at several points, make small marks and then draw the line freehand.

EMPHASIZING STRUCTURE

Sometimes you may want to give a little extra detail or emphasis to features such as walls or trellises. You can add detail with a fine brush, but this can make the painting look overworked. Another method is to combine drawing and painting. I have used touches of pen and ink here and there in the painting of Denmans Gardens, but you can use anything that gives a solid line – felt-tipped pen, pastel pencil, conté pencil or an ordinary drawing pencil.

Use line sparingly, however, as an unbroken, insensitive line can destroy any impression of spontaneity and detract from the translucency of the watercolour. It is also best not to restrict drawn line to just one area of the picture, as this can isolate the feature, making it stand out more than you want it to and spoiling the picture's unity.

▲ The Pergola, West Dean Gardens
28 × 38 cm (11 × 15 in)
Here again the man-made features provide the perfect foil for the twisting shapes of purple clematis. Apart from this, I particularly liked the suggestion of looking out from a semi-enclosed space; the pergola has something of the quality of an interior – a room with a view over large trees outside. I chose the viewpoint with this in mind. A closer view, omitting the roof beams and some of the pillars, would not have conveyed the impression so well.

WATER FEATURES

Many parks and gardens have lakes, ponds or fountains, and some even feature waterfalls. As landscape gardeners know, water is always an appealing subject, with the knack of bringing a garden to life, and the same applies to your painting.

REFLECTIONS

On a completely still day, a pond or lake will provide a perfect mirror image of the landscape above it. This occurs rarely, and when it does it is a breathtaking sight. But it does not always make for a good painting. If reflections are too perfect they will look unnatural and you will lose the feeling of the water surface, so it is wise to break up the reflections in places by suggesting a ripple or two. You can do this by reserving the occasional stripe of white paper in the foreground or making a few small squiggling darker brush strokes.

▲ Waterlilies
28 × 35.5 cm (11 × 14 in)
I did not want the water to be too prominent in this painting. What I liked was the almost abstract pattern formed by the elegant flagstones, the long, flat lily leaves and the rounded waterlilies. To stress this I chose a high viewpoint. I began with the dark blue of the water and the pondweed, as this defined the roundness of the lily leaves, and from there progressed to the latticework of shadows. I worked mainly on dry paper as the edges needed to be crisp.

◀ Fountain in Regent's Park
22 × 25 cm (8¾ × 9¾ in)
I was in a hurry when I painted this, as it was a cold day in early spring. The sun was bright, however, catching the jets of water and picking out the pattern on the sombre grey fountain. I left the jets of water until the end of the picture, made sure the paint was fully dry, and then scratched into the paint with a craft knife. Because the knife has scuffed the paper surface, the result is a series of broken lines highly suggestive of lines of spray.

Reflections on a rippled surface are more exciting to paint but they are more difficult, because the pattern is complex, added to which it is always changing. The best way of tackling such subjects is to spend some time observing, and when you come to paint, try to simplify. The surest way to lose the wetness of water is to overwork the paint, so use an edited 'language' of dots, and wiggly strokes – on dry paper so that the edges are crisp and clear.

FAST-MOVING WATER

The rule of careful observation applies even more to waterfalls or rushing streams. You won't see reflections in this case because the water surface is churned up and uneven, but you will begin to see patterns in the way it behaves. The water in a fast-flowing stream, for example, will curl around rocks in the same way each time; it will not suddenly decide to change direction.

With a waterfall, the main danger is making the body of white water look frozen and static, as it often does when you take a photograph. Look for the main shape, reserve it as white paper initially, and then break up the mass with just a suggestion of brush strokes in dilute colour.

USEFUL TECHNIQUES

Several of the techniques shown on pages 20 and 21 can help you depict water without overworking. For small highlights such as the tops of ripples catching the light, try small brushmarks of masking fluid, removing them when the subsequent washes have dried. Fine spray can be achieved by scratching out, as I have done for my painting of a fountain. For the soft effect of a gentle gleam of light on distant water – perhaps a large lake – a light application of wax resist works well, or you could lift out the highlight with a piece of cotton wool or a sponge. Finally, exploit both the wet-into-wet and the wet-on-dry method depending on the subject – the former for soft, diffused effects and the latter for crisp edges.

GARDEN DETAILS

While painting garden scenes you have probably noticed the general garden clutter of tools, wheelbarrows, stacks of canes and netting and so on, a welcome antidote to all that well-organized beauty. These present numerous opportunities for making interesting small-scale studies, or sketches you can incorporate into larger paintings.

Garden tools carelessly left protruding from flowerbeds may look out of place and untidy in a grand country-house garden, but in a humbler one – a vegetable patch, perhaps, or your own garden after a session of digging – they are a natural part of the scenery. A wheelbarrow or spade can often form an interesting focal point, and will also add to the overall atmosphere. Don't forget that gardens are a partnership between humankind and nature, and featuring tools in your painting, hinting at recent human endeavour, is the next best thing to putting in a figure digging.

GARDEN STILL LIFE

Still life is a branch of painting that takes inanimate objects as its subject matter. Still-life groups are usually set up indoors, but they don't have to be; you can make an unusual painting from a group of garden tools, flowerpots, or garden furniture, such as a couple of empty deckchairs on a lawn. In the latter case, you could make the painting tell a subtle story – leaving an open book, magazine or newspaper on one of the chairs to suggest that the occupant was enjoying relaxing in the sun but had been called away for some reason. There are all sort of ways of bringing people into your pictures without actually painting them.

▲ *I painted the study of the spade plunged into the soil because it is such a familiar feature of the ordinary garden. I think this sketch stands as a painting in its own right, whereas without the spade the painting would be as ordinary as the garden. The watering cans, tray of seed pots and fence would all make useful details in a painting, so I took care over them; there is nothing more frustrating than inadequate visual reference.*

To take another approach, you could bring the garden indoors, making a still life from a pair of Wellington boots on a doormat, with gardening gloves beside them, or a basket of newly picked fruit or vegetables on the kitchen table. Rows of seedlings or cuttings on a windowsill can make an unconventional painting, and don't forget the endless possibilities of the garden shed or the greenhouse, both inside and out.

MAKING STUDIES

Spend a day or an afternoon now and then sketching these utilitarian objects and out-of-the-way corners. Watering cans, trays of seedling pots, coiled hoses, a garden gate, weeds growing from walls or pushing up through paving stones, rubbish stacked in bags, or even the compost heap, all have possibilities as subjects. Aim for a sketchbook full of small drawings, with touches of paint to remind you of the colours. When your book is full, look through it and try to analyse which of the sketches you could incorporate into a painting and which would stand well on their own. Time spent sketching is never wasted, because apart from building up a store of visual reference, you are also polishing your drawing skills and learning to look at things in new ways.

▲ *These are shown exactly as I painted them, scattered across the page. Until I started I had no idea how compelling I would find boots, dustbins, rubber hoses and old stacking trays, but as I worked they came to life. The group of boots and shoes has good possibilities as a still life, and could be worked up into a finished painting, while the splashes of bright colour from plastic bin liners and rubber hoses could provide a suitable accent in a painting with an otherwise muted colour scheme.*

▲ I made this small garden still-life sketch mainly because the shoes struck my eye. I often feel that gardens or garden subjects look more natural with people in them, and the shoes are a substitute for a human presence. The picture also hints at a story; from the watering can and open door the viewer knows that the lush plants have just been attended to, and the light, bright colours leave no doubt about the season and weather conditions.